IDIOT'S
GUIDES.
AS EASY AS IT GETS!

GoPro®
Cameras

WITHDRAWN

by Chad Fahs

ALPHA

A member of Penguin Random House LLC

Publisher: Mike Sanders
Associate Publisher: Billy Fields
Acquisitions Editor: Jan Lynn
Development Editor: Kayla Dugger
Cover and Book Designer: Lindsay Dobbs
Photographer: Chad Fahs
Prepress Technician: Brian Massey
Proofreader: Laura Caddell
Indexer: Celia McCoy

First American Edition, 2016
Published in the United States by DK Publishing
6081 E. 82nd Street, Indianapolis, Indiana 46250

ISBN: 978-1-61564-893-1

Library of Congress Catalog Card Number: 20155954787

DK books are available at special discounts when purchased in bulk for sales promotions, premiums, fund-raising, or educational use. For details, contact:
DK Publishing Special Markets, 345 Hudson Street, New York, New York 10014 or SpecialSales@dk.com.

Printed and bound in China

idiotsguides.com

Contents

Introduction

Each April, film and television professionals from around the world flock to the Las Vegas Convention Center on Paradise Road in Las Vegas, Nevada, to ogle the latest production gear, pixel-peep monitors, and eat overpriced, undercooked pizza.

In recent years, visitors to this city within a city are drawn to the Central Hall by the enthusiastic rumblings of a large crowd. It's here that GoPro's booth packs in the faithful, encouraging their cultlike chants ("GoPro, GoPro, GoPro!") with free raffles and slick displays of base-jumping daredevils, bikini-clad surfers, and parkour acrobats.

Only a few years ago, GoPros were considered a toy by many in the industry. Today, GoPro cameras are used in professional productions as disposable crash cams, mounted on drones for epic aerials, or placed in other hard-to-reach locations for unique shots. Their small size and immersive 4K imagery mesh well with high-end tools. In a world where smartphones shoot 4K cinematic images, the line between amateur and professional is as blurred as a night on the Strip in Las Vegas.

Personally, I'm less interested in obsessing over specs and more excited by making things. Cameras are tools, which help us tell stories or capture a moment. There's a reason why we take more photos with iPhones than DSLRs these days, and now quality doesn't have to suffer. In this book, I show you how an action camera like the GoPro opens up new ways to see your world. I first go over how your camera works, followed by discussion of how to edit your work in GoPro studio. Finally, I give you some projects that let you put your knowledge to the test. Hopefully this book will inspire you to create images of your own. Now go make something!

ACKNOWLEDGMENTS

I'd like to thank my partner in crime, Meghann Matwichuk, for helping me through every stage of the writing process. I'd also like to thank the Grotti family (Meg, John, Jack, and Sam) for their contributions, particularly with the playground project. And to my parents, Berit and Gerald, who are a constant source of encouragement and support.

Part 1: Getting Started with GoPro

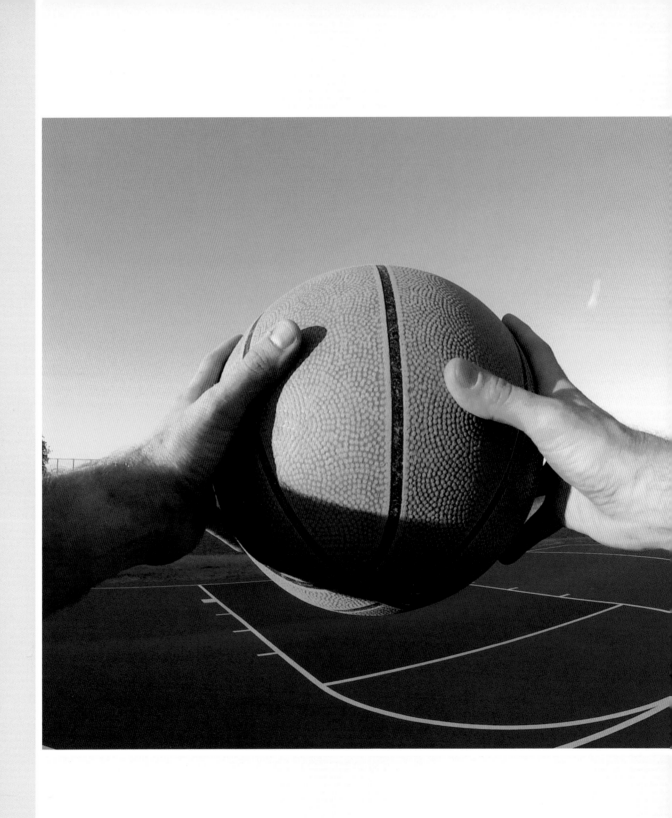

Chapter 1: GoPro Basics

"Seagull Stole My GoPro," "World's Highest Free Fall," "Avalanche Cliff Jump," "Backflip Over Canyon," and "Lion Hug"—what do all of these titles have in common? These ultra-wide, point-of-view action shots have become synonymous with the GoPro. With its small size, tough exterior, and versatile mounting options, a GoPro camera is the perfect lifestyle product for today's active users. In an age of hyperbolic advertising copy, it really is a go-anywhere, do-anything camera.

Yet perhaps the GoPro's most amazing feature is its ability to make even the mundane seem exciting. The technology that miniaturized high-definition video and 4K optics has probably seen its biggest use around the home and in other casual settings. Birthday parties and holidays have never looked as cinematic, and vacations at the beach so epic, as when recorded by a GoPro camera. So whether you're a professional filmmaker, a casual hobbyist, or an extreme athlete, a GoPro is a handy item to have in your toolkit.

GoPro: **Company and Culture**

Founded in 2002 by Nick Woodman, an avid surfer, GoPro was created to capture extreme sports in an up-close-and-personal way. However, as the GoPro transitioned over time from being an analog camera using 35mm film to a digital, 4K-shooting powerhouse, the possible uses for Nick's device likewise began to grow. Today, GoPro is a publicly traded company, with products available everywhere and millions of cameras sold.

Not Simply a Camera—A Lifestyle

As Nick shared in the *Forbes* article "How Nick Woodman Modeled GoPro After Red Bell," GoPro's goal is to celebrate its users. Basically, what people shoot is just as important as the GoPro camera with which they do it. In an age of fast-paced technology, GoPro has thrived, with users sharing their footage on GoPro's website and on other social media outlets.

GoPro on YouTube

One of the most popular of those outlets is GoPro's YouTube channel (youtube.com/user/GoProCamera), which is rapidly approaching 4 million subscribers. On this site, the company shares the best user-generated content, as well as tutorials on how to use the various GoPro cameras.

What Can You Do with a GoPro?

GoPro cameras are a versatile alternative to larger, heavier devices. They cope well with the elements, can fit into tight spaces, and have attachments to help you easily protect and maneuver them. Whether you're participating in extreme sports or hanging out at home, you're challenged to experiment and explore with GoPro, going where no camera has gone before.

Action and Adventure

The GoPro offers waterproof capabilities and customizable mounting options that make action-and-adventure pursuits like the following possible:

- Rock climbing
- Surfing
- Snow boarding
- Running
- Kayaking

The Everyday

At the same time, GoPros are suitable for everyday uses. You can get a lot of use out of your GoPro recording activities like the following in new and interesting ways:

- Making home movies
- Taking a road trip
- Preparing food
- Documenting home or car repairs
- Creating a time lapse of the sky

GoPro **Camera Models**

In the action camera category alone, GoPro has marketed and sold (in its relatively short history) more than 20 basic camera models. To help you whittle down your options right away, the following are the six most current GoPro models available.

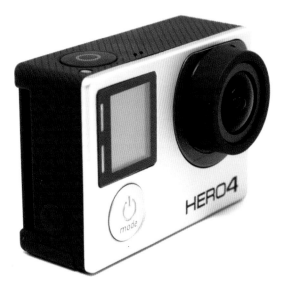

Hero4 Black

At the high end of GoPro's lineup is the Hero4 Black. This camera—which was used to take the project shots in this book—is designed for the user who doesn't like to compromise on quality. It's the only GoPro that currently supports proper 4K shooting, as well as very high frame rates at lower resolutions. While it doesn't include an LCD screen, the Hero4 Black provides the most features of any GoPro camera model.

Hero4 Silver

The Hero4 Silver camera is a popular choice, due to the addition of a fixed LCD screen on its back. This screen lets you control your camera, frame your shots, and review video clips all in one place—no outside accessories required. Like the Hero4 Black, the Hero4 Silver includes built-in WiFi and Bluetooth, allowing you to wirelessly transfer, watch, and edit photos or videos, as well as share them online. However, the maximum frame rate is lower than the Hero4 Black, making this camera the best option for users who don't require proper 4K video.

Hero4 Session

Fifty percent smaller and 40 percent lighter than other GoPro models, the Hero4 Session is perfect for wearing and mounting. This waterproof camera includes two microphones—one facing forward and one facing backward—and switches between the two for the best results in windy environments. A built-in battery contributes to the sleek design, although it limits long recording sessions. While the Hero4 Session works with the standard GoPro mounts, not every accessory can be applied to the camera (including cases, which it doesn't need anyway). Also, its maximum recording resolutions and frame rates are lower than the Black and Silver models.

Hero+ LCD

If you're a beginner-level camera user who wants a built-in battery; touchscreen; and rugged, all-in-one design (in which the camera is built into the waterproof case), the Hero+ LCD is a good choice. It's equipped with WiFi and Bluetooth so you can preview and share your shots like you can with the more advanced GoPro models. However, the Hero+ LCD has more limited video resolution and doesn't support the use of external mics.

Hero+

As you can probably guess from the name, the Hero+ shares all of the features of the Hero+ LCD except for one: the LCD screen. So if you like the Hero+ LCD but don't require the screen—or want to save money— check out this model.

Hero

The Hero is another all-in-one design in which the camera is built into a waterproof case and has a nonremovable battery. This no-frills, entry-level GoPro camera lacks WiFi and Bluetooth (meaning no previews or external controls are possible), as well as the ability to shoot at high resolutions. However, its significantly lower cost in comparison to other GoPro models makes the Hero a great camera for a day at the beach or around the house.

GoPro Recording Media

In order to record with a GoPro, you'll need a MicroSD card with a Class 10 or UHS-1 rating. This card is smaller than a fingernail but can hold a surprising amount of data. The exact speed and storage specifications you'll need depend on your camera and the type of recording you want to do. Cards that are listed as MicroSDXC are generally the fastest, and when looking at the class speed (U1 or U3, for example), the higher number is best. When it comes to storage, 64GB will give you about 130 to 260 minutes of recording time depending on resolution.

GoPro **Video Specifications**

Now that you know the basics about the current models, it's time to take a look at the video options available to you. Increased resolution and higher frame rates are just two areas where GoPros have seen significant advancement.

Video Resolutions

The resolution you choose affects the amount of detail in your shot. Video resolution is measured in pixels, or individual dots that form a single frame within your video. For example, 4K has a frame size of 4,096 by 2,160 pixels, which means the frame contains close to 9 million pixels (4096 × 2160). So the higher the number of pixels, the better the quality of your footage.

Depending on the camera model, 16:9 aspect-ratio image options include 4K (4096 × 2160), 2.7K (2704 × 1520), 1080p (1920 × 1080), 720p (1280 × 720), and WVGA (848 × 480). GoPro cameras also have a 4:3 aspect ratio, though only the standard 16:9 aspect ratio makes use of their center portion. Fortunately, GoPro offers full-height, 4:3 image options on most of its cameras—think taller frames, which capture more vertical information of a scene. These resolutions include 960p (1280 × 960), 1440p (1920 × 1440), and 2.7K 4:3 (2704 × 2028).

SuperView

GoPro developed the much-touted SuperView mode to squeeze 4:3 aspect-ratio video into a 16:9 frame. This feature provides dramatic views not possible with most cameras. However, if you prefer to avoid automatic squeezing of your content using SuperView, the standard 4:3 modes can be cropped or squeezed later on in GoPro Studio.

Video Frame Rates

The number of frames per second (fps) is a measure of how many pictures the camera is capturing every second. Faster fps create a video with smoother motion—or even slow motion if you're using a high-enough frame rate (such as 120 and 240 fps)—when played back at normal rates. Slower fps, such as 24 and 30, are more typical of what you're accustomed to in movie and television content respectively. Most users find 48 and 60 fps to be ideal frame rates for the majority of activities involving motion. The video resolution you choose determines your available frame rates. Lower resolutions offer the most options for higher frame rates, because processing and writing video files is less intensive.

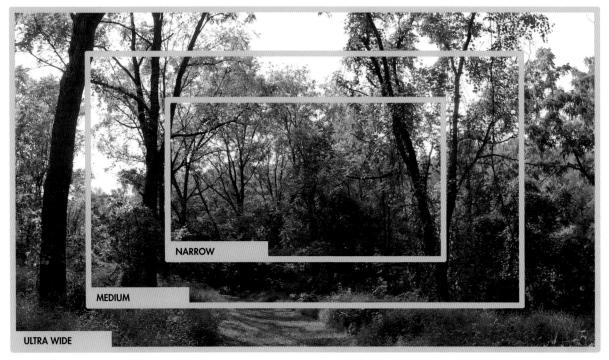

Field of View (FOV)

Field of view (FOV) is the amount of a scene that's visible. The GoPro expresses this using the terms *Ultra Wide, Medium,* and *Narrow*. When a GoPro uses the Ultra Wide FOV, it's using the full height and width of the sensor for the chosen aspect ratio. When you select Medium, the sensor is cropped a bit to provide a view that's less wide or slightly more zoomed in. Choosing Narrow crops the image even further. Using Medium or Narrow FOV is similar to changing the focal length on a lens, except the GoPro is cropping the image digitally, not optically. One drawback of cropping a sensor digitally is a reduction in quality, as it magnifies noise and reduces sharpness.

Settings Warning

When working with resolution, frame rate, and FOV together, having the best of all is rarely possible. For instance, while making a 4K, 24 fps, Ultra Wide video is doable, you'd end up with a very large video file that requires a great deal of memory to store. So experiment with different combinations to see what gives you the quality you want at a file size that's workable.

GoPro **Photo Specifications**

Apart from its use as a video camera, GoPros offer still photo capture. In fact, a GoPro's photo features (such as those found in Multi-Shot mode) contain some of its most powerful capabilities.

Photo Resolutions

Photo resolutions differ somewhat from their video counterparts because they utilize the 4:3 aspect ratio (as opposed to the usual 16:9 aspect ratio for video) and have higher pixel counts overall. The default resolution for the Hero4 Black and Silver are 12MP (4,000 × 3000) with an Ultra Wide FOV, followed by 7MP (3,000 × 2250) with either an Ultra Wide or Medium FOV and 5MP (2560 × 1920) with a Medium FOV. Other cameras in the lineup will differ. The Hero4 Session, for example, has a default of 8MP (3264 × 2448) at an Ultra Wide FOV, as well as 5MP (2720 × 2040) with a Medium FOV.

Continuous, Night, and Multi-Shot Modes

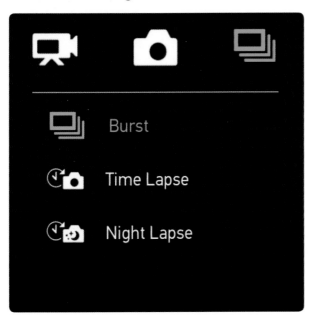

Beyond photo quality options, GoPros also have different photo shooting modes with which you should be familiar: Continuous, Night, and Multi-Shot.

With Continuous, you can continuously take photos at preset intervals until the shutter button is released. Typically, you can choose from intervals of 3, 5, or 10 photos every second. In Night mode, you can capture long exposures of up to 30 seconds, which is great for shots of the sky at night.

Even more interesting is Multi-Shot mode, which enables features such as Burst, Time Lapse, and Night Lapse. The Burst option quickly grabs 3, 5, 10, or 30 shots over a duration of 1, 2, or 3 seconds; this makes it great for capturing fast action. Time Lapse and Night Lapse both take photos at set intervals ranging from 0.5 to 60 seconds. When played back, they simulate the passage of time, such as clouds moving overhead.

GoPro **Playback and Control Features**

Of course, without the ability to play back or control your camera, it wouldn't be of much use. While you can press physical buttons on the GoPro to start and stop recording or change modes, wireless controls and LCD touchscreens provide more options for camera operation.

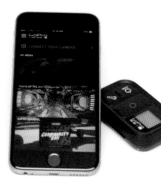

Wireless Controls

If your camera is equipped with WiFi and Bluetooth, you have multiple options for controlling it wirelessly. One of the more popular options is Smart Remote, which allows you to trigger recording and change settings from a distance. iPhone, iPad, and Android users can also download the GoPro app and use it to control the camera instead. With the app, it's possible to not only make changes to the settings and trigger recording, but also to preview and review your shots. (Smart Remote and the GoPro app will be discussed more later.)

LCD Screens

Obviously, inclusion of an LCD screen is a major factor when making a purchasing decision. LCD screens are great for quickly lining up your shots and accessing menus without the hassle of apps. Some GoPro cameras—such as the Hero4 Silver and the Hero+ LCD—come equipped with a built-in LCD screen for instant monitoring, playback, and control of your camera's many settings. For most GoPros that ship without a screen installed, you can purchase an LCD BacPac (discussed more later in this book)—which easily snaps into the back of the camera—to add this functionality. However, I should note that while the immediate views are nice, LCD screens deplete your battery more quickly.

Choosing the **Right Camera**

	HERO4 BLACK	HERO4 SILVER	HERO4 SESSION
PRICE	Highest	High	Middle
VIDEO RESOLUTION FRAME RATES (IN FPS); FIELD OF VIEW (FOV)			
4K	30, 25, 24; Ultra Wide	15, 12.5; Ultra Wide	n/a; n/a
4K SUPERVIEW	24; Ultra Wide	n/a; n/a	n/a; n/a
2.7K	60, 50, 48, 30, 25, 24; Ultra Wide, Medium	30, 25, 24; Ultra Wide, Medium	n/a; n/a
2.7K SUPERVIEW	30, 25; Ultra Wide	n/a; n/a	n/a; n/a
2.7K 4:3	30, 25; Ultra Wide	n/a; n/a	n/a; n/a
1440P	80, 60, 50, 48, 30, 25, 24; Ultra Wide	48, 30, 25, 24; Ultra Wide	30, 25; Ultra Wide
1080P	120, 90, 60, 50, 48, 30, 25, 24; Ultra Wide, Medium, Narrow	60, 50, 48, 30, 25, 24; Ultra Wide, Medium, Narrow	60, 50, 30, 25; Ultra Wide, Medium
1080P SUPERVIEW	80, 60, 50, 48, 30, 25, 24; Ultra Wide	60, 50, 48, 30, 25, 24; Ultra Wide	48, 30, 25; Ultra Wide
960P	120, 60, 50; Ultra Wide	100, 60, 50; Ultra Wide	60, 50, 30, 25; Ultra Wide
720P	240, 120, 60, 50, 30, 25; Ultra Wide, Medium, Narrow	120, 60, 50, 30, 25; Ultra Wide, Medium, Narrow	100, 60, 50, 30, 25; Ultra Wide, Medium
720P SUPERVIEW	120, 60, 50; Ultra Wide	100, 60, 50; Ultra Wide	60, 50, 30, 25; Ultra Wide
WVGA	240; Ultra Wide	240; Ultra Wide	120, 100; Ultra Wide
PHOTO RESOLUTIONS			
MEGAPIXELS	12MP	12MP	8MP
BURST RATES (FRAMES/SEC)	30/1, 30/2, 30/3, 30/6, 10/1, 10/2, 10/3, 5/1, 3/1	30/1, 30/2, 30/3, 30/6, 10/1, 10/2, 10/3, 5/1, 3/1	10/1, 10/2, 5/1, 3/1
TIME LAPSE INTERVALS (IN SEC)	0.5, 1, 2, 5, 10, 30, 60	0.5, 1, 2, 5, 10, 30, 60	0.5, 1, 2, 5, 10, 30, 60
CONTINUOUS PHOTO RATES	10/1, 5/1, 3/1	10/1, 5/1, 3/1	n/a
WIFI AND BLUETOOTH AVAILABLE	Yes	Yes	Yes

Now that you've had a chance to learn about the models and photo and video specifications offered by GoPro, you might be wondering which camera would best meet your needs. The following table lists the different features of the six current GoPro models along with their price (based on a highest-to-lowest scale) for comparison.

	HERO+ LCD	HERO+	HERO
	Middle	Low	Lowest
VIDEO RESOLUTION FRAME RATES (IN FPS); FIELD OF VIEW (FOV)			
4K	n/a; n/a	n/a; n/a	n/a; n/a
4K SUPERVIEW	n/a; n/a	n/a; n/a	n/a; n/a
2.7K	n/a; n/a	n/a; n/a	n/a; n/a
2.7K SUPERVIEW	n/a; n/a	n/a; n/a	n/a; n/a
2.7K 4:3	n/a; n/a	n/a; n/a	n/a; n/a
1440P	n/a; n/a	n/a; n/a	n/a; n/a
1080P	60, 50, 30, 25; Ultra Wide	60, 50, 30, 25; Ultra Wide	30, 25; Ultra Wide
1080P SUPERVIEW	n/a; n/a	n/a; n/a	n/a; n/a
960P	n/a; n/a	n/a; n/a	n/a; n/a
720P	60, 50; Ultra Wide	60, 50; Ultra Wide	60, 50; Ultra Wide
720P SUPERVIEW	60, 50; Ultra Wide	60, 50; Ultra Wide	60, 50; Ultra Wide
WVGA	n/a; n/a	n/a; n/a	n/a; n/a
PHOTO RESOLUTIONS			
MEGAPIXELS	8MP	8MP	5MP
BURST RATES (FRAMES/SEC)	10/2	10/2	10/2
TIME LAPSE INTERVALS (IN SEC)	0.5, 1, 2, 5, 10, 30, 60	0.5, 1, 2, 5, 10, 30, 60	0.5
CONTINUOUS PHOTO RATES	n/a	n/a	n/a
WIFI AND BLUETOOTH AVAILABLE	Yes	Yes	No

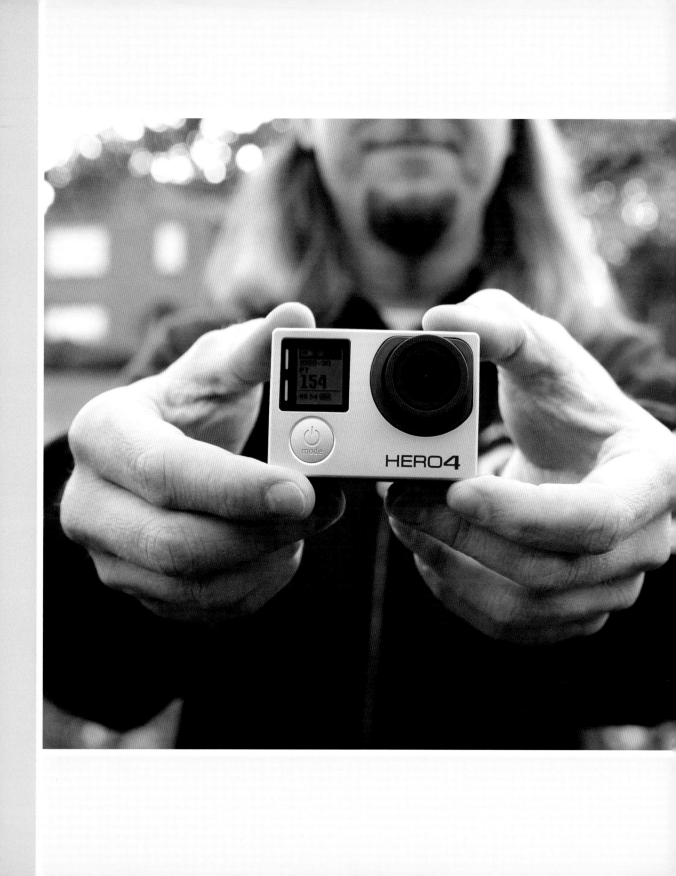

Chapter 2: Quickly Setting Up Your GoPro Camera

Whether you've purchased a GoPro or received one as a gift, you may feel like you don't know where to start. It's time to stop staring at the box and put the camera through its paces. After all, GoPros are made for action!

This chapter gives you instructions on unboxing and readying your camera for use. You then learn how to set up your GoPro for basic shooting with features such as QuikCapture. Particularly if you're working with one of the entry-level GoPros, you should find this covers the majority of your needs. In fact, after a few minutes working with it, you'll wonder why you didn't fire it up sooner.

Taking Your GoPro **Out of the Box**

GoPro packaging for the Hero4 cameras is set up so the camera is displayed in a sort of plastic fishbowl on top of the box, which makes for a nice profile on the shelf. A few pieces of tape are all that hold the plastic top and the box together, so simply peel off the tape and remove the top. The camera is firmly secured to a plastic base with a special buckle. To detach the camera from the buckle, press in the tabs on each side of the buckle and lift the camera up and away. When removing your camera from its box, use care to save all of the pieces that are hiding underneath (including various mounts, stickers, and instruction booklets).

Removing Your Camera from Its Housing

Once detached from the box, you should get your GoPro *au naturel*—a.k.a., remove it from its housing— so you can charge the battery and add a memory card. To do this, lift up and snap open the large black latch on top of the housing. Place your hand over the opening and gently shake the camera loose of the plastic and into your hand.

Saving Box Pieces

Once you remove your camera from the buckle and plastic base, you can cut out this section of the box and use it as a handy mounting plate during special projects. You can also save the plastic top and use that to store miscellaneous accessories and other small pieces that came with your camera.

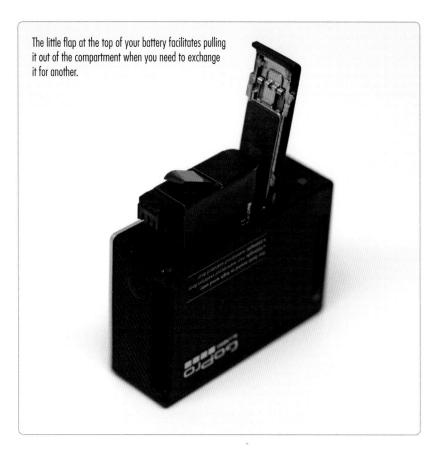

The little flap at the top of your battery facilitates pulling it out of the compartment when you need to exchange it for another.

Charging
the Battery

Before using your GoPro, make sure to fully charge its battery. Insert the battery into your camera by sliding open the battery door on the bottom of the camera and slipping it in with its pins facing to match the pins in the compartment. Push down the battery and close the battery door.

To charge the battery, remove your camera's side cover to reveal the external connections and plug in the USB cable included with your camera. You'll need a USB power adapter to plug your cable into the wall, or you can plug the USB cable directly into your computer. A red LED light on your GoPro will tell you it's charging. Once the light turns off, the battery is fully charged.

The memory card simply slides into a small slot on the side of the camera.

Inserting a **Memory Card**

When you're ready to insert the memory card, remove the side cover on your camera to reveal the external connections and memory card slot. Insert the card with its printed face toward the lens. If this is a new card, or if you'd like to wipe and reuse an old card, make sure to format it in the camera before using (you can do this in Setup mode, which is discussed later in this chapter).

Readying Your GoPro

Once you've charged the battery and put a memory card inside your GoPro, you're ready to turn on and input some basic settings.

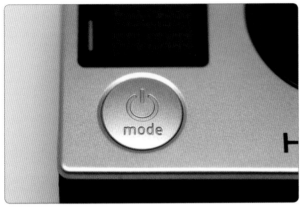

POWER/MODE BUTTON

Turning On the GoPro

To turn on your camera, simply press and hold the Power/Mode button. Later, when you're finished using the camera, you'll turn it off in the same way—simply by pressing and holding the button.

Navigating the Modes and Menus

Pressing the Power/Mode button while the camera is on cycles through the modes available on your camera. On the Hero4, these include Video, Photo, Multi-Shot, Playback, and Setup. Each of these modes has additional capture modes and settings. Scroll through these modes and menus to get a general sense of what's available to you; I'll explain more about what they're for throughout this book.

Camera Status Lights and Sound Indicators

When turning on your camera, you probably noticed how its status lights flashed and a beep sounded three times; this indicates it has power. Alternately, when you power off your GoPro, you'll hear seven beeps. Recording and functions such as WiFi may cause the status lights and beeps to activate as well.

If you'd like to turn off these status lights or lower the volume of the sound indicators, cycle through the modes using the Power/Mode button until you get to Setup mode, and then select either LEDS (status lights) or BEEPS (sound indicators) by pressing the Shutter/Select button.

Setting Time and Date

The date and time are added to all your photo and video files to indicate when they were created. So making sure to set up these correctly will ensure your files are easier to find later on. This is just one of many options you can find in the Setup mode.

1. Press the Power/Mode button to cycle through modes.

2. When you arrive at Setup, press the Shutter/Select button to choose it.

3. Using the Power/Mode button, move down the list of menu items until you arrive at an icon that looks like a calendar. Press the Shutter/Select button to go into its settings, and alternate between the Power/Mode and Shutter/Select buttons to move between and select date or time menu options and fields.

While this may seem like a lot of button presses, you'll get faster at it as you get familiar with your camera. You also have the option of navigating modes and adjusting settings with the GoPro app (discussed later in this chapter) or the LCD screen (if your camera has one), which may seem more intuitive and quicker if you're experienced with them.

SHUTTER/SELECT BUTTON

SETTINGS/TAG BUTTON

Turning WiFi On and Off

You can quickly and easily toggle your camera's WiFi function on and off by holding down the Settings/Tag button on the side of your GoPro for a few seconds. When a blue status light flashes, it means WiFi is enabled. Simply repeat the same process when you're ready to turn off the WiFi. It's important to turn off the WiFi when it's not in use, as it drains the camera battery.

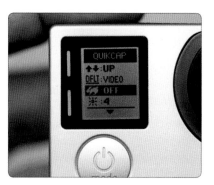

Using QuikCapture

Capturing spontaneous moments is easiest with QuikCapture. You can enable this feature by scrolling to and selecting Setup mode, selecting the rabbit icon (abbreviated as "QUIKCAP"), and turning it On. Once it's enabled, a single press of the Shutter/Select button turns on the camera and begins recording video. Another press of the Shutter/Select button stops recording and automatically turns the camera off, conserving power until your next session. And if you hold down the Shutter/Select button for a few seconds, you activate Time Lapse photos.

Getting the **GoPro App**

If your camera has WiFi capabilities (which is every model mentioned in this book except the entry-level Hero), you can use the GoPro app on an iOS or Android device to operate your camera. This gives you a wireless monitor and access to all of your camera's settings. It's probably the best way to use your camera, at least when you want to set up your shot or immediately review and share your files after recording. Because the camera creates its own WiFi connection no matter where you are, you don't need access to a network to use the GoPro app with your camera.

Installing the GoPro App

In order to install the app, you first need to find it in the online app store for your iOS or Android device. Simply search using the keyword "GoPro" and then download the app.

Pairing Your Camera with GoPro App

Before using the GoPro app, you need to change a few settings on your camera.

1. With your GoPro turned on, press the Power/Mode button until you get to Setup mode. Select it by pressing the Shutter/Select button.

2. At the top of the Setup menu, choose Wireless by pressing the Shutter/Select button.

3. Make sure WiFi is switched to On and the RC+App mode is activated. If they aren't, use the Power/Mode button to move down the list and use the Shutter/Select button to select and activate them.

4. Press the Settings/Tag button to exit.

Setting Up the App

The following steps enable your camera and phone or tablet to communicate with each other.

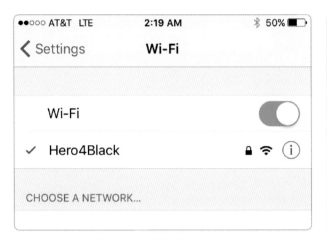

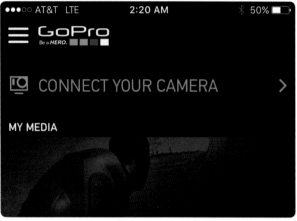

1. On your phone or tablet device, go to the WiFi settings and select the Hero4 camera as the network you want to connect to. Start up the GoPro app on your device.

2. Choose Connect Your Camera from the top of the app's first screen.

GoPro with Apple Watch

Just recently, the GoPro app became compatible with Apple Watch. Through this, you can use your Apple Watch as a viewfinder to frame your shots, to start or stop recording, and to capture photos, along with other features.

3. On the Choose a Device screen, select the camera you want to connect to the app. When the connection is complete, you should see a live preview from your camera.

Recording a Short Video

Now that your GoPro is charged and ready and the GoPro app is installed, it's time to test it out by recording a short video. A few simple steps are all that are necessary to capture video with a GoPro. Once you're satisfied with the basic mode and menu settings, you simply press the Shutter/Select button and let it rip. For utmost clarity, the following steps illustrate the process you'll normally follow for recording.

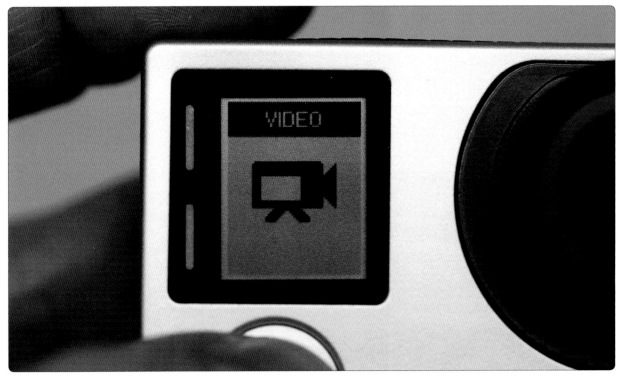

1. Select Video Mode

Press the Power/Mode button until Video mode is selected. You'll know you're in Video mode when you see the icon of a camera with a tripod in the top-left corner of your camera's status screen.

2. Access and Optionally Alter Mode Settings

To access settings for Video mode, press the Settings/ Tag button on the side of your camera. When you're in the settings menu, press the Power/Mode button to move down through the list of possible shooting options. Look at the information on your camera's status screen to determine whether the current default settings are satisfactory. A resolution of 1080p, an fps of 30 or 60, and an FOV of Ultra Wide (abbreviated as W) are great starting points—and typically the defaults.

If they're not the defaults, or if you have other settings you'd like to use, make your adjustments using the Power/Mode button to move down the list and the Shutter/Select button to cycle through settings for each option. (Options toward the bottom of the settings menu can be ignored for now.) When you're finished making any adjustments, press the Settings/Tag button to leave this menu and return to shooting, or choose the Exit option at the bottom of the list.

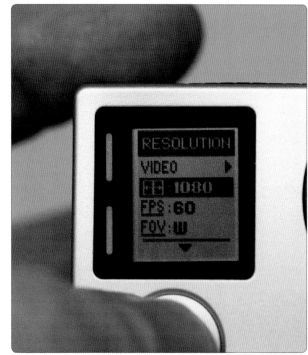

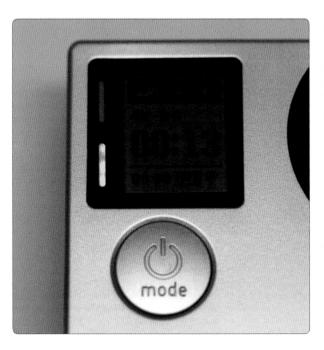

3. Time to Shoot!

Now you're ready to shoot. Point your GoPro at something interesting and press the Shutter/Select button to start shooting. You'll see a camera status light to indicate that recording has begun. The camera status screen will also show you the length of time you've been recording.

4. Stop Recording

When you're ready to stop recording, simply press the Shutter/Select button. At this point, you can preview your files on an LCD screen or with the GoPro app, or transfer the video files to your computer for editing or upload to the video-sharing site of your choice.

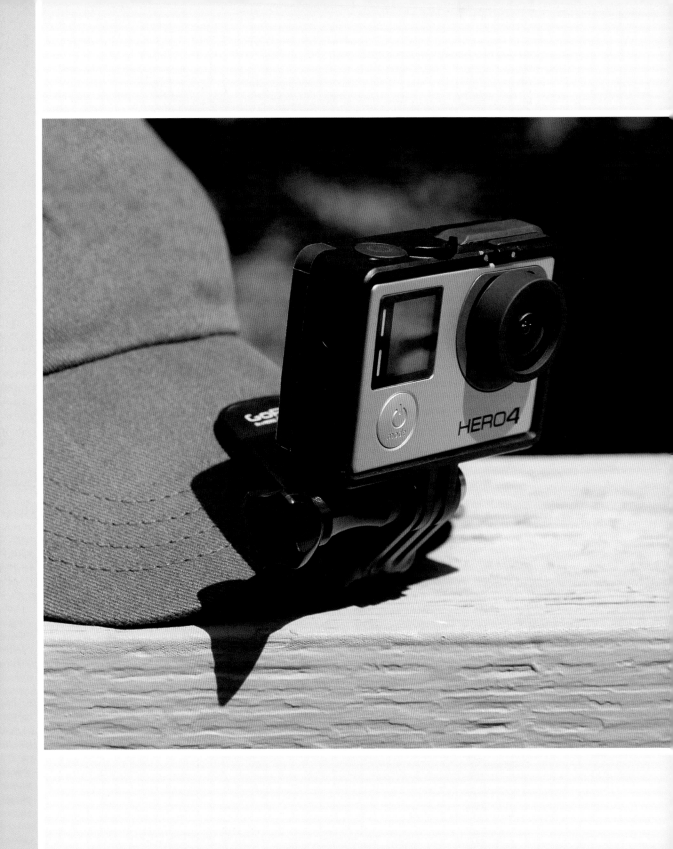

Chapter 3: Mounting and Wearing Your GoPro

Putting a GoPro on your body or attaching it to one of the other, seemingly infinite number of locations is a big part of its appeal. Of course, where you place it and how it's connected to that point can be a challenge without the proper mount. Fortunately, GoPro makes mounts that work for almost any scenario you can dream up. Whether you use a mount once for a special shot or choose to permanently affix it to gear for repeated use, mounts can add new capabilities to your GoPro, opening up additional possibilities for shooting.

While cheaper alternatives from other companies may exist, this chapter covers mostly official GoPro mounts. The GoPro brand stamped on a product means it's been tested and approved by GoPro, which adds some peace of mind, particularly when you're attaching your camera to a stick of plastic and sending it hurtling down a mountain, submerging it in a massive wave, or letting it cruise on the exterior of a vehicle. Plus, even acquiring just a few GoPro mounts should go a long way for capturing all sorts of amazing shots.

Attaching a GoPro to Surfaces

While many specialized mounts are available, you can use a simple adhesive mount to attach your GoPro to various surfaces. This is particularly useful for longer-term usage, as well as for getting the camera flush to a surface.

Curved and Flat Adhesive Mounts

The Curved and Flat Adhesive Mounts may come packaged with your camera, or they can be purchased separately. These are the standard, semipermanent mounts, with very strong (industrial-strength) adhesive by 3M. As their names imply, you match the mount to the appropriate—curved or flat—surface. Whatever the surface, make sure to clean it thoroughly before sticking the mount to it. Once you've peeled off the backing tape, carefully position the mount and firmly press it down. Before you take it out for a spin, I recommend you wait at least 24 hours for the adhesive to set. To remove the mount, simply use a hair dryer to heat the adhesive and then peel it off.

Removable Instrument Mounts

While the Curved and Flat Adhesive Mounts are great, they can be a bit difficult to remove; they may leave behind some residue or pull off the veneer, causing cosmetic damage. For both of these reasons, you should probably avoid using them on an instrument or any other surface that could be easily harmed. To keep that paint job in shape, you can use a Removable Instrument Mount instead. Although this mount can hold your camera securely, its adhesive is a sort of gummy consistency and therefore easy to remove. When you're ready to take it off the instrument, simply pull the tab backward to stretch the adhesive parallel to the mount; this safely releases it from your instrument.

Mount Adhesive

Once you've used and removed a mount, the adhesive needs to be replaced. Some mounts, like the three-pack of Removable Instrument Mounts, come with extra adhesive strips. However, any additional strips for mounts require purchasing another retail package. You can find the adhesive at any hardware store or by searching for "3M part number 4991 VHB" online.

Hand Grips and Extension Arms

For people on the move, it's important to have a mount that's as agile and adaptable as they are. Grips and extensions are nimble mounts that allow you to use a GoPro without having to lug around a bunch of bulky equipment.

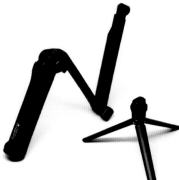

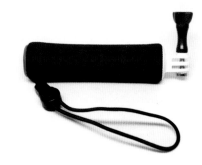

3-Way

As far as unconventional camera mounts, nothing GoPro sells is as strange and versatile as their 3-Way product. Described by the company as a 3-in-1 camera mount that transforms from a simple short-handled camera grip into an extension arm or a tripod, its compact design is perfect for the traveler or sports enthusiast. Is your arm not long enough for that perfect selfie or point-of-view shot? At 20 inches (50cm) extended, the 3-Way could do the trick. Need a tabletop tripod you won't be tempted to leave at home? The 3-Way collapses to 7½ inches (19cm). It's also waterproof, meaning the 3-Way will work just about anywhere, indoors or outdoors, you need some extra reach or support.

The Handler (Floating Hand Grip)

Getting steady handheld shots with a GoPro can be tricky. One of the simplest solutions is using a basic handheld grip to better stabilize your shots—at least compared to holding the bare camera in your hands. The Handler is not only a basic handgrip for use on land, it's also a seaworthy, waterproof (up to 33 feet; 10m) companion for your camera that floats. This makes it perfect for filming water sports (such as snorkeling and kayaking) or for anytime you want to shoot around water worry free. Want to sip a cerveza poolside while you shoot your next opus? The Handler comes with The Tool, a GoPro thumb screw wrench and bottle opener.

Jibs and Cranes

So-called "action jibs" or cranes provide additional extension over a typical selfie stick, along with control of the camera's tilt via an adjustable platform. Most of the jibs made for GoPro cameras are lightweight, making it easy to use handheld over a crowd during an event or in any other scenarios you want high-angle shots. Joby and MicroJib are examples of companies that offer these devices.

Attaching a GoPro to **Tripods and Stands**

There's something to be said for traditional mounting options. Attaching your GoPro to a tripod or other type of stand is a virtual necessity for many photographers and filmmakers, professional and amateur alike.

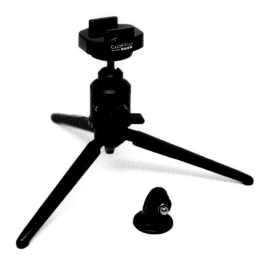

Tripod Mounts

By far, the most common and most used mount for cameras is a standard 1/4-20 (¼-inch; .5cm diameter, 20-thread) tripod connection. Practically any camera you buy will have one built in—with the exception of a GoPro. This makes sense, because attachments for the GoPro are on the cases, which are often body mounted and have unique requirements. Also, the extra real estate for a tripod screw would eat into the camera's already limited space for internal components. Instead, you can simply add a Tripod Mount to adapt your camera to any tripod or similar support gear you might have.

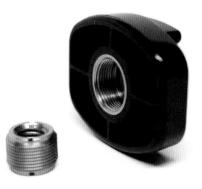

Mic Stand Mount

While not as universal as a tripod mount, the 5/8-27 Mic Stand Mount (or 3/8-16, with an included adapter) is a great alternative for performance environments where mic stands are plentiful. A mic stand may also be a cheaper alternative to a full-size tripod, particularly when used with a camera as light as the GoPro. The extra height and extension possibilities can come in handy as well.

Gyroscopic Stabilizers

Action shots with a handheld or moving camera are notoriously shaky without some sort of stabilization. Whether you're walking, running, or shooting on a moving vehicle, the camera will almost always be unsteady (usually quite a bit). In recent years, gyroscopic stabilizer technology, which was developed for drones, has evolved into handheld systems that can hold a wide range of cameras—including GoPros. One popular brand for GoPro cameras is Feiyu Tech. However, you can find many other companies selling similar handheld stabilizers that are often rebranded versions of generic devices.

Gyroscopic stabilizers are immensely popular among both amateur and professional filmmakers for good reason. Once you've mounted and balanced your camera on one of these devices, its brushless motors will compensate for motion (yaw, pitch, and roll) and create buttery-smooth camera movement with a level horizon. This means you can shoot perfectly steady handheld shots while running down a street, walking up a flight of stairs, riding your bike on the trails, or following the action on the basketball court.

Steadicams

If you'd rather use a less-expensive stabilizer that doesn't require batteries (and may even fit in your pocket), consider a Steadicam Curve or similar device. Once balanced, these mounts help isolate the camera from the operator's movements, creating smooth, handheld shots for a variety of actions.

Attaching a GoPro to **Impromptu Locations**

Oftentimes, mounting situations can be unpredictable and difficult, which is why bendable and adaptable mounts are an important addition to your GoPro toolkit. If you aren't planning to mount the camera on your body but want a stationary mounting point or unusual angle, consider the following options.

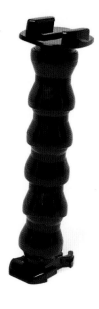

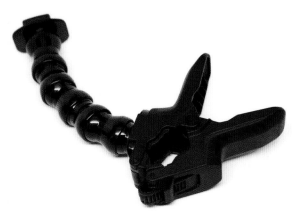

Gooseneck

The firm yet flexible Gooseneck mount is available separately. It can be attached to any of the standard GoPro mounts with a quick-release base or even to another Gooseneck for added reach. Measuring 8 inches (20cm), the Gooseneck can bend over, under, and around obstacles and can even be used as an impromptu handheld camera grip. Most often, it's used in combination with the Jaws: Flex Clamp.

Jaws: Flex Clamp

If you had to pick just one GoPro mount, the Jaws: Flex Clamp would be a great choice. Quickly and safely attaching a GoPro camera to the widest number of places requires a versatile and strong mounting option. The Jaws: Flex Clamp achieves this with a simple spring-loaded mechanism that grips objects ranging from ¼ inch to 2 inches (.5 to 5cm) in diameter with soft rubber teeth that clamp tightly but won't damage most surfaces. The flexible Gooseneck, which is detachable and included with this mount, allows you to place the camera in a variety of positions, no matter how awkward. Getting a precise shooting angle has never been easier.

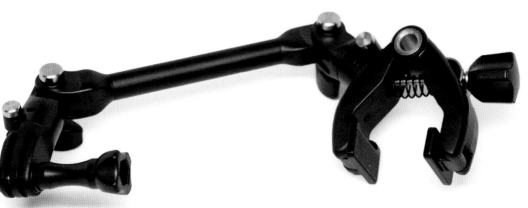

The Jam (Adjustable Music Mount)

Designed to work well with many different instruments, The Jam is a bit more specialized than the Jaws: Flex Clamp. By reconfiguring the mount in different lengths, you can attach it to guitars, drums, keyboards, and mic stands. Its thin, lightweight design makes it easier to mount on guitars and similar handheld instruments but still able to stay firmly in place. The Jam can be purchased separately or as part of a "music bundle."

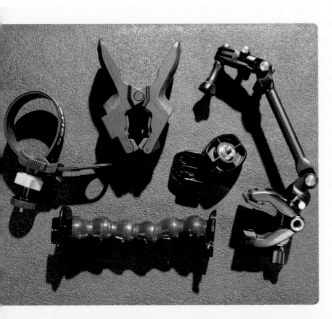

Music Bundles

The GoPro Music Bundle is currently available for the Hero4 Black, Hero4 Silver, and Hero4 Session cameras. If you're purchasing the bundle with a Hero4 Black or Silver, it comes with The Jam (Adjustable Music Mount), the Jaws: Flex Clamp, a rechargeable battery, and a 64GB (Hero4 Black) or 32GB microSDXC card (Hero4 Silver). If you're purchasing the bundle with a Hero4 Session, it comes with a Mic Stand Mount and Removable Instrument Mounts along with the 32GB microSDXC card.

Mounting a GoPro on a **Vehicle**

Whether you want to re-create a scene from *Mad Max* or simply document your latest road trip, you'll need a way to mount your camera on a vehicle—preferably a method that's secure yet easily removable. Whether you're using a car, bicycle, or anything else with wheels, it just so happens that many of these modes of transportation have bars and smooth surfaces that are perfect for attaching small camera mounts.

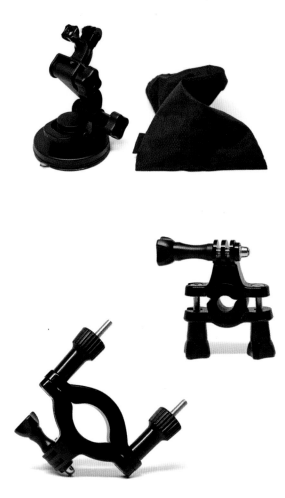

Suction Cup

Slick, flat surfaces—like metal, glass, and some plastics—can make ideal mounting points for the Suction Cup. This could easily fall into the category of impromptu mounting locations mentioned earlier in this chapter. More often than not, however, the Suction Cup is attached to the window or body of a car, the surface of a kayak, or some other moving vehicle. When mounting the Suction Cup on potentially precarious locations, use a camera tether to secure it.

Handlebar/Seatpost/Pole Mount

The Handlebar/Seatpost/Pole Mount is designed to work best with smaller poles, bars, pipes, and tubes like those found on a bicycle or motorcycle. Ski poles, painter's poles, and many other items of similar size can be used with this mount to achieve interesting angles, and the included 3-Way Pivot Arm makes alignment much easier overall. Out of the box, the clamp fits bars and tubes from ¾ inch to 1⅖ inches (.5 to 3.5cm) in diameter. If you use the included adapter, it can work with smaller tubes measuring ⁴³⁄₁₀₀ to ⁷⁄₁₀ inch (1.1 to 1.75cm) as well. It's also fitted with a soft lining that protects surfaces while gripping them snugly, preventing damage to their paint job or chrome handlebars.

Roll Bar Mount

The Roll Bar Mount is designed for larger pipes and tubes measuring 1⅖ to 2½ inches (3.5 to 6.25cm), including those found on bicycle frames, roof racks, cages on cars, boards for windsurfing, and more. Really, this mount works for anything larger than the Handlebar/Seatpost/Pole Mount can handle. The 3-Way Pivot Arm is included with this mount as well, which is useful for precise aiming. Interior padding on this mount grips and protects surfaces at the same time.

Mounting a GoPro on **Sports Equipment**

Many of the mounts already discussed can be used for mounting your GoPro to a wide variety of sports equipment. The Curved and Flat Adhesive Mounts, for example, are great for mounting your camera on different boards and helmets, and the Handlebar/Seatpost/Pole Mount, as well as the Roll Bar Mount, cover many other sports apparatus. However, many instances of shooting could still benefit from a specialized mount, particularly within the areas of surfing, bodyboarding, archery, target shooting, and fishing.

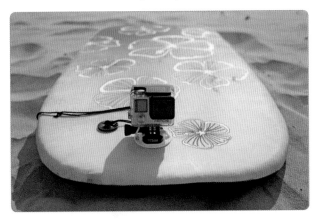

Bodyboard Mount

The Bodyboard Mount securely attaches your GoPro to soft-top or foam bodyboards and surfboards measuring 1½ to 3½ inches (3.75 to 9cm) thick. It's a perfect mount for capturing views from the front of your board, looking backward at yourself, or looking forward at the water. Installation is simple and foolproof. However, once installed, the mount shouldn't be removed, as it creates a hole in your board for the screw attachment. Also included with this mount are a camera tether and a locking plug to better secure the mount.

Surfboard Mount

If you're going to use a GoPro on a surfboard, boat, or other craft exposed to water, your safest option is the Surfboard Mount. The adhesive on this mount offers maximum holding strength and can stand up to prolonged usage in the water. After installing the mount and waiting at least 24 hours, you're ready to test it out on some serious waves. Anchors and camera tethers are included for additional security and peace of mind.

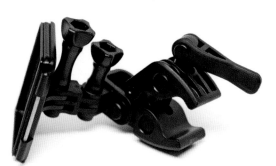

Sportsman Mount

Some of the trickiest shots with a GoPro involve guns, bows, and fishing rods, which is why the Sportsman Mount was created. The Sportsman Mount is able to keep the camera as close as possible to the barrel or bow while reducing recoil and shock using a special backdoor with a built-in, stabilizing mount. If you have multiple GoPros, you can also mount front- and rear-facing cameras simultaneously. A lot of mounting hardware is included with this mount, such as miscellaneous backdoors and brackets for proper alignment. The Sportsman Mount supports bow components, fishing rod grips, and firearms with diameters of ⅖ to ⁹⁄₁₀ inch (1 to 2.3cm).

Wearing a GoPro on Your Body

Probably the most common usage for a GoPro, you can mount it somewhere on your body, creating a first-person point of view from your head, chest, or limbs. Several mounts can help you achieve the perfect perspective, depending on the activity and your comfort level.

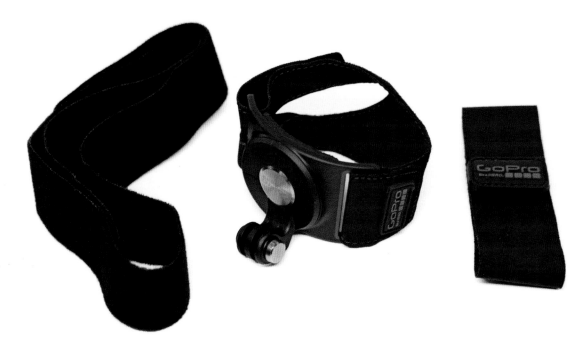

The Strap (Hand + Wrist + Arm + Leg Mount)

The Strap is a highly versatile mount for attaching a GoPro to your body in or out of the water. It's easy to hold, and the camera can be rotated and tilted quickly on the mount without removing it. This mount is a great option for that perfect selfie while in the midst of the action. You can even capture activities from your arm, leg, or wrist by attaching the camera to one of the extended straps included with the package.

Wrist Housing

When a secure fit and easy access are paramount—particularly in high-adrenaline activities like surfing, snowboarding, skydiving, or climbing—consider wearing your GoPro like a watch with the dedicated Wrist Housing. The Wrist Housing keeps your hands unencumbered yet gives you the flexibility to pivot the camera into an upright position when needed. You can also use it for underwater activities (like snorkeling). The mount even attaches to other gear, including paddles and kite-surfing kites.

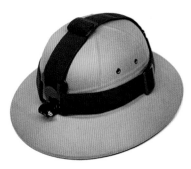

Head Strap and Quick Clip

The Head Strap is great for hands-free, point-of-view shots. Its position on your head is about as close as you're going to get to an accurate approximation of human vision, particularly when the camera is in the upside-down orientation. The strap is easily adjustable to fit most user's heads and can be placed over a helmet. While it's great for achieving that "you are there" perspective, the Head Strap can be a bit uncomfortable to wear and attention grabbing in public because of its headlamp-looking design.

If the Head Strap is too restrictive, or if you'd like something you can take on and off your head without much fuss, consider using the QuickClip, which is packaged with the Head Strap. The QuickClip is primarily designed to be worn on the brim or back of a hat, such as a baseball cap. As opposed to the Head Strap, however, the QuickClip lacks a truly secure connection to its mounting point and can slip off a hat when subjected to high-impact activities like running and jumping. Therefore, consider using it for sports like golf or possibly skateboarding.

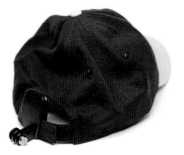

Helmet Front Mount

The Helmet Front Mount is designed to do what it says—mount a GoPro to the surface of a helmet, providing a classic point of view for activities like kayaking and skiing. Think of it like the Head Strap without the strap—it's the same headlamp position, but with a more permanent mounting point. One of the benefits of this mount versus simply placing the Head Strap over top of the helmet is that it offers an extendable arm. This arm can be used to turn the camera around to face you or to adjust the angle for more extreme forward views.

Vented Helmet Strap Mount

If your helmet has vents as opposed to a solid surface for attaching your camera, a Vented Helmet Strap Mount is likely your best choice. If you do a lot of biking, your helmet probably has these vents through which you can pass the one-size-fits-all straps for easy mounting and adjustment. However, its angles are a bit more limited compared to similar mounts.

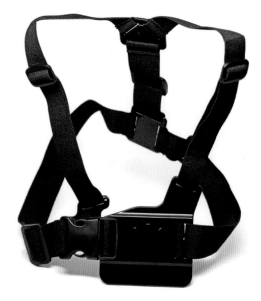

Side Mount

For a mount with easy, three-way adjustability, look no further. The Side Mount positions your GoPro at right angles that are tricky for other mounts, particularly in such a low profile piece. Essentially, what you get is a Curved Adhesive Mount and a 3-Way Pivot Arm, along with a basic Quick Release Buckle and Thumb Screw. This mount works well on helmets and on vehicles where adhesives are acceptable.

NVG Mount (Helmet with Night Vision Goggles)

The NVG Mount is a bit more specialized, because it requires a helmet with this style of mounting plate (which is normally found on the helmets of military or police officers). If your helmet has an NVG mounting plate, you can easily attach a GoPro to it while maintaining the lowest possible profile. If you like the options offered by an NVG Mount, you might choose to purchase an NVG helmet specifically for use with a GoPro.

Chesty (Chest Harness)

Possibly the most useful mount for placing a GoPro on your body is the Chesty. This mount gives an immersive feeling to point-of-view shots, keeping the action close enough that the perspective feels somewhat natural. It's ideal for activities like biking, playing the piano, documenting a hands-on project, or anything else where you want to capture your arms in the action. In general, the harness is an alternative to the Head Strap, which can be too high and less interesting for certain activities. The Chesty is also adjustable and comfortable enough (in a snug way) to leave on for extended periods of times.

Junior Chesty (Chest Harness)

The Junior Chesty offers the same benefits as the full-size adult version, except it's designed for kids ages 3 and up weighing 25 to 115 pounds (11.5 to 52kg). Adjustable like the adult version, this harness is a great option for an afternoon at the park with the kids or running around the backyard.

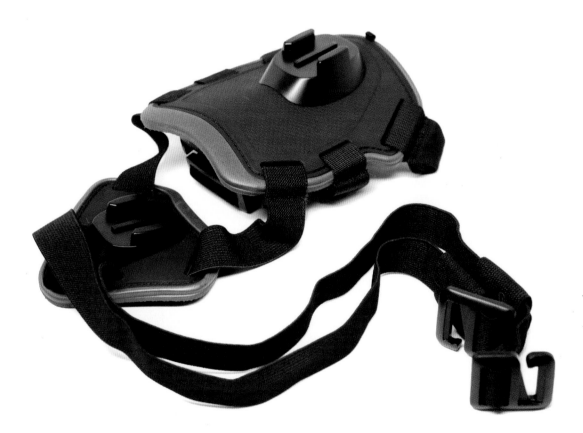

Fetch (Dog Harness)

Why should humans have all the fun? For many of us, dogs are another member of the family. The Fetch is like the Chesty and Head Strap for humans redesigned for dogs, allowing our canine companions to get in the middle of the action. The harness includes two mounting points—chest and back. The chest-mounted camera is great for activities like eating, chewing, pulling, and digging, which can provide views of the paws (depending on the angle). Using the back-

mounted camera, you can capture over-the-head views of running, jumping, and swimming, to name just a few canine pastimes. The harness is designed to fit dogs weighing between 15 and 120 pounds (7 and 54.5kg), with the chest mount removable for added clearance with smaller breeds. To make cleanup easier, the harness is washable and should stand up to most wet and muddy outdoor pursuits.

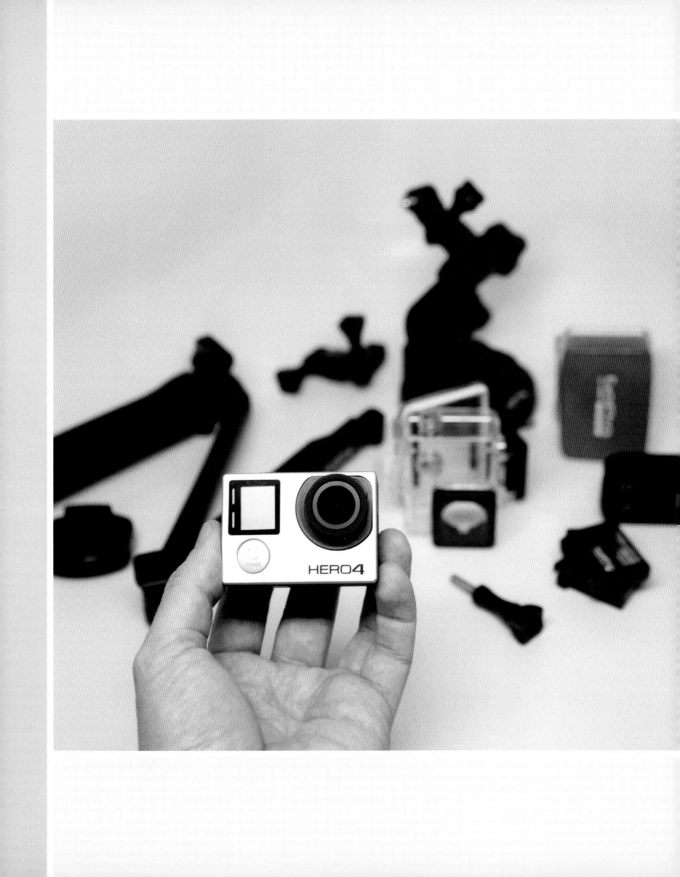

Chapter 4: Accessorizing Your GoPro

In addition to any mounts you might consider, accessories are what make a camera really hum. Sure, you can do a lot with your GoPro right out of the box. However, to bring out a GoPro's full potential and to help maintain it, you may need to add some items to your shopping list. Learning about the various accessories and options available for your GoPro can teach you as much about the capabilities and limitations of your existing hardware as it can about the new products themselves.

In this chapter, I cover most of the standard pieces you'll need (or want) to operate your GoPro. From remote controls and cables to covers and cases, they're all here. Obviously, it's not possible to cover every option that's available, but this should give you a good starting point. Ultimately, powering, protecting, enhancing, and fixing your GoPro are all part of responsible ownership.

Powering Your GoPro

The last thing you want to worry about while exploring a distant city or the ski slopes is how to keep your GoPro running, so the following lists what you need to charge and maintain your GoPro's power.

GoPros are power-hungry devices, particularly when using high frame rates, 4K recording, LCD screens, and WiFi at the same time. Certain GoPro models—such as the Hero, Hero+, Hero+ LCD, and Hero4 Session—are a special case, because they have built-in batteries. However, even those often require an additional power source to keep up.

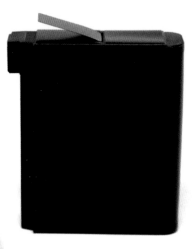

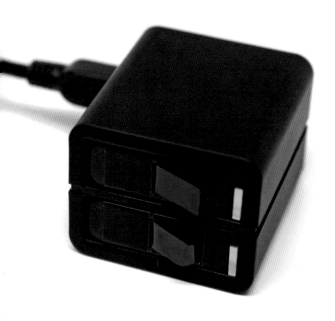

Rechargeable Battery

If your GoPro comes with a removable battery, it's important to have at least one spare on hand. While GoPro estimates that each battery can last for about 1 to 1½ hours on average, it's common for batteries to last for much less than 1 hour, particularly when using more advanced features. Cold weather also affects battery life. A standard GoPro-branded battery for the Hero4 has a rating of 1160mA, 3.8V, and 4.4Wh, which is less than a typical smartphone.

Dual Battery Charger

When you have multiple batteries, there's nothing more annoying than having to constantly switch them out on a standard charger, particularly if you want to charge them at night while you're sleeping. The Dual Battery Charger takes some of the hassle out of the process by simultaneously charging two batteries.

Wall Charger

In order to charge a camera with the battery inside or to use the Dual Battery Charger, you need to attach your USB cable to a USB power adapter that plugs into the wall (or, alternately, your computer). While GoPro does not provide one of these with your camera, you can purchase their wall charger accessory or use another brand—just make sure it outputs 5V and 1A.

Battery BacPac

In lieu of an extra battery (or in addition to it), consider adding a Battery BacPac to your GoPro. The Battery BacPac effectively doubles the power to your camera (adding 1240mAh). However, its extra thickness will require a different door for the back of your cases, which GoPro provides.

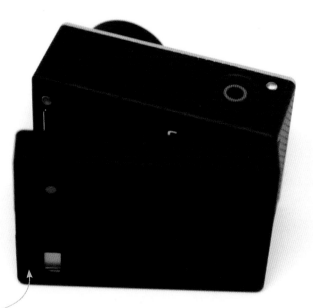

A special backdoor helps fit the Battery BacPac.

Using a USB Battery Pack

A USB battery pack is an essential source of power while on the go. GoPro sells the Portable Power Pack (6000mAh), which charges a GoPro about four times. However, you'll save a lot of money (and get extra charging power to boot) by buying a different brand.

Charging Cables

In order to charge your devices (GoPro cameras, Battery BacPac, Dual Battery Charger, and so on), you'll need a USB cable that has a full-size USB 2.0 connection on one end and a Mini USB connection on the other. If you decide to purchase the Smart Remote (discussed later in this chapter), it requires a specially designed USB cable.

A USB battery pack can supply power to maintain your GoPro.

Smart Remote

When using body-mounted or otherwise inaccessible GoPro cameras, or when you want to trigger recording without touching the camera, consider the waterproof Smart Remote.

The Smart Remote allows you to control one or more GoPro cameras remotely—up to 50 cameras at a time, at a distance of up to 600 feet (180m). Its small screen exactly mirrors what you see on your GoPro's front screen and eliminates the hassles associated with the GoPro app (such as losing WiFi connectivity or damaging your phone by getting it wet or dropping it). You can start and stop recording, change modes, make new settings, and more, just as you would if the camera were in your hands. Included with the remote are a key ring and a wrist strap. Both are useful for attaching the device to your body while engaged in action sports, or for anytime you just want to have it easily available.

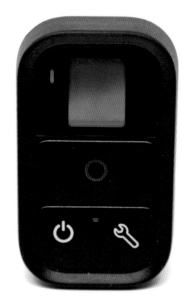

Charging the Smart Remote

Before using the Smart Remote, make sure it's fully charged. This is something you should check even if you haven't used the remote in a while, as the battery tends to drain quickly while left on the shelf. Charging of the remote requires a special USB cable (included with the Smart Remote) with a strange hook-shaped connector on one end. Before you hook the connector to your Smart Remote, however, you need to remove the key ring attachment, if it's still in the device. To do this, simply press the release button and slide out the silver ring.

Once you've removed the key ring, connect the connector to your Smart Remote, making sure it clicks into place. In the same way you charged the battery for your camera, connect the other end of the cable to a USB power adapter and plug it into the wall.

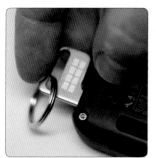

REMOVE THE KEY RING
Press the release button to remove it so you can connect the USB cable.

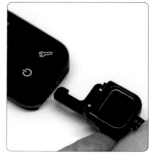

INSERT THE USB CABLE
The special hook connects into the Smart Remote and clicks into place.

Pairing Your GoPro with the Smart Remote

With your Smart Remote charged and the camera powered on, it's time to pair it with your GoPro.

1. With your GoPro turned on, press the Power/Mode button three times to find the Setup mode. Press the Shutter/Select button to enter it.

2. At the top of Setup, press the Shutter/Select button to choose Wireless.

3. Use the Power/Mode button to move down the list to Pair. Press the Shutter/Select button.

4. Press the Power/Mode button once to move down to Wi-Fi RC and press the Shutter/Select button. At this point, you should see a three-minute countdown that indicates the pairing process has been initiated.

5. Turn on the power for your Smart Remote by pressing its own Power/Mode button. If this is the first time the remote has been paired, it will automatically detect your GoPro and you're done!

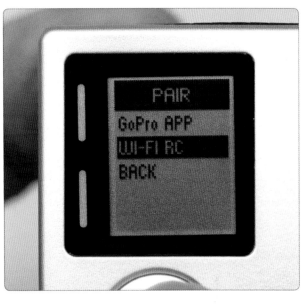

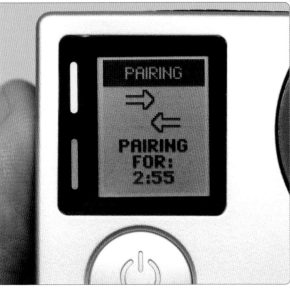

Pairing Again?

If it has been paired with the device before, press and hold the Settings button on the remote for a few seconds to activate the pairing, followed by the Shutter/Select button on the remote once the camera has completed the pairing process.

LCD Touch BacPac

Want the extra feedback and ease of use that comes with having an LCD screen? The LCD Touch BacPac replicates the experience of a built-in screen but attaches (and detaches) easily to the back of the camera.

Some GoPro cameras come with an LCD screen built in, such as the Hero4 Silver and the Hero+ LCD. However, for the Hero4 Black, as well as some legacy GoPro cameras, you can add a screen with the LCD Touch BacPac. Once attached, you can frame your shots without using the GoPro app and adjust your camera settings using touch screen controls. It also gives you the option of playing back your videos in slow motion, allowing you to review your footage as thoroughly as you'd like. The LCD Touch BacPac even includes a built-in speaker with volume control and a headphone jack, which are useful for monitoring the sound you capture.

In order to use the LCD Touch BacPac, your camera needs to be bare or mounted in The Frame or Standard Housing (discussed later in this chapter) with the special Touch BacPac Backdoors (included with purchase). With the added advantages of playback, preview, and control, you can expect that the screen will use up more of your battery, so use the LCD Touch BacPac judiciously. To help save on the battery life, you can always adjust the brightness down.

The LCD Touch BacPac gives you the flexibility to preview, frame, and play back your GoPro footage.

Other Devices for
Monitoring Your Video

Although it's most convenient to monitor your video recording with one of the built-in or removable LCD screens attached to your GoPro, other ways are available to see what you're recording.

The most obvious choice is the GoPro app on an iPhone or iPad. This is a nice alternative, and one that most users are familiar with. You can also use one of the WiFi-enabled viewers from companies like Removu, which puts an LCD screen on your wrist or anywhere else it's needed. The WiFi capabilities of the camera make these options (and, inevitably, future options) possible.

You can also use a Micro HDMI cable connected to your GoPro to attach it to both consumer and professional displays, or even video recorders, such as those sold by Atomos (such as the Ninja 2) or Blackmagic Design (such as the Video Assist). This means any HDTV or portable monitor that has HDMI inputs (HDMI connector sizes may vary by device) can offer onset previews or playback from your camera. Seeing a large, high-quality picture from your GoPro gives you confidence you're getting the shots you want. Unfortunately, you won't be able to view 4K or 2.7K video via the HDMI connection. GoPro Hero4 cameras use the HDMI 1.3a connection standard, which maxes out at 1080p resolution.

Protecting Your GoPro
from the Elements

GoPros are subjected to some of the most incredible abuse—and I mean that in the best way possible. No matter where you go, you'll want to bring your GoPro along, which means water, sand, and snow will take their toll unless proper measures are taken to protect your intrepid soldier.

In most cases, a special camera housing suited to the conditions and requirements of your project will do the job for you. You can augment these housings with a variety of accessories that should help you get the shot no matter what the environment has in store.

Screen Protectors

If you have a camera with a built-in LCD or with an LCD BacPac attachment, it can be difficult to keep the screen clean and free of scratches. Using one of the Hero4 Silver Screen Protectors can help keep smudges (and damage) to a minimum.

Protective Lenses and Covers

You wouldn't store your nice DSLR lens without the lens cap on, would you? Yet we do it all the time with our GoPros, even though the plastic cases are more easily scratched. If you're using your camera naked or in The Frame (discussed later in this chapter), consider using the Protective Lens. Otherwise, use one of the covers designed specifically for your camera's housing (purchased separately or as part of the Protective Lens + Covers Kit from GoPro).

The Protective Lens keeps your GoPro lens from being damaged or scratched.

Standard Housing

Every GoPro camera sold comes with some type of housing by default. Certain cameras—such as the Hero, Hero+, Hero+ LCD, and Hero4 Session—have housings built into the design. For all other cameras, a Standard Housing ships with the device. Compared to other plastic housings GoPro makes, this is one of the slimmest. It's designed to be your go-to housing whenever water or dirt is a factor.

The case is waterproof to 131 feet (40m), with a flat glass lens that allows images to be sharp even below water. The Standard Housing comes with backdoors that can be swapped out when using an LCD screen (Touch Backdoors) or when requiring access to ports (Skeleton Backdoor).

Blackout Housing

GoPro cameras and their cases tend to be somewhat shiny and reflective. However, some users would rather the camera stay hidden. The Blackout Housing has a nonreflective, matte black finish, which is less distracting and blends in better with the background. It also has stickers to place over the LCD screen to cut down on light leaks. In every other way, this housing is similar to the Standard Housing, including being waterproof to 131 feet (40m).

Skeleton Housing

Live video feeds of an event require access to an AV connection, and many other scenarios require constant charging. Open sides provide direct connections to the USB, HDMI, and MicroSD card slot. At the same time, an open case improves cooling and enables better audio capture with the built-in camera microphone (when wind isn't a factor). The Skeleton Housing allows this openness. It's designed for situations in which you don't require waterproof capabilities but would still like to protect your camera and have access to its ports.

Dive Housing

For underwater filming, the Dive Housing is hard to beat. Its waterproof rating is to a depth of 197 feet (60m), and its rugged design—with a sturdier casing than the Standard Housing—handles deep-sea diving very well. Serious divers will find its flat lens design gives sharper images, especially close up. In fact, there's no reason why you shouldn't use this housing for any underwater filming you do, even in a pool.

WindSlayer (Foam Windscreen)

The WindSlayer is a stretchy foam camera wrap that works with The Frame housing or the camera alone to reduce wind noise affecting the camera's built-in microphone.

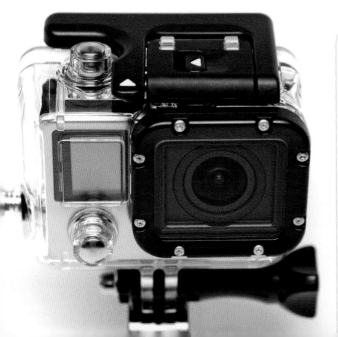

Maintaining Waterproof Housings

Like the Standard Housing and Dive Housing, the o-ring on a waterproof housing keeps the water out, especially under high pressure. Make sure this seal around the backdoor is kept clean and free of debris like sand by cleaning it out after trips to the beach. You may also choose to store your case in the open position to maintain the longevity of the o-ring seal.

The Frame

While it's nice to have the option of super-durable housings, you don't always need that level of safety. When you're using your GoPro indoors or in situations where the elements aren't a factor, The Frame housing is generally preferable.

Only a slight amount of plastic surrounds the perimeter of the camera, making the housing compact and very light. Its no-fuss, open design provides access to all ports for live video, charging, and the offload of MicroSD cards, as well as clear audio capture using the camera's built-in microphone. At the same time, you still have a solid connection for the usual GoPro mounts and accessories. Adding an LCD Touch BacPac or Battery BacPac is also simple without a backdoor to worry about. Low-impact sports, music videos and events, and casual shooting around the house are ideal for this housing.

Getting the camera in and out of The Frame is a snap (literally). A single latch is all it takes to free the camera and slip it out of the housing, making it a convenient choice for everyday shooting. Because the lens is otherwise exposed in this housing, the package also comes with a Protective Lens.

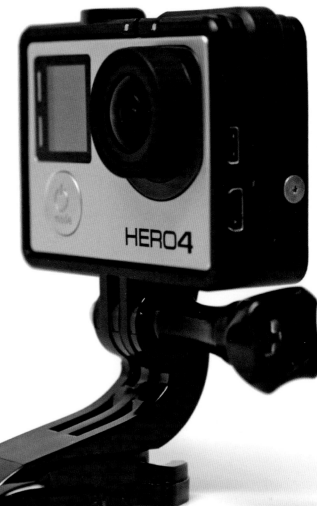

Cages

Companies like Redrock Micro sell cages, which are basically tough exoskeletons that wrap around your camera and include mounting points for additional accessories. Cages are primarily useful for users who want to attach professional camera gear to their GoPro or for reinforced protection.

Dual Hero System

For users interested in shooting 3D images or simply curious about what's available for GoPro cameras, there's the Dual Hero System.

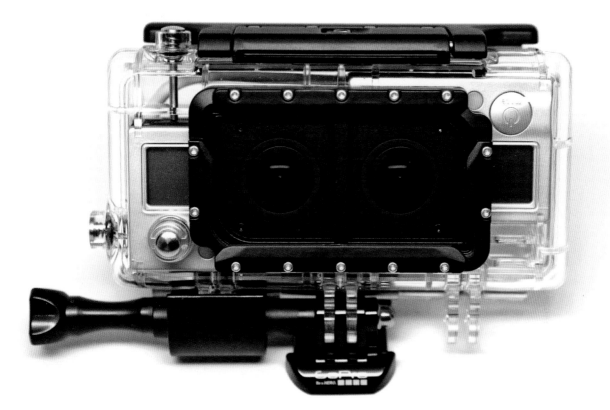

The Dual Hero System can be used to produce 3D video and photos, although the current version of the housing only works with legacy cameras (specifically, the Hero3+ Black Edition). By using two GoPro cameras in a special housing, 3D capture becomes more approachable and economical than working with a dedicated system. The case is designed to synchronize image capture, controlling features of both cameras simultaneously. Like the Dive Housing, the Dual Hero System is also waterproof to 197 feet (60m). It comes with both Standard and Skeleton Backdoors, as well as miscellaneous mounting hardware, cables, and 3D anaglyph (red/blue) glasses for viewing. If you're interested in producing content for 3D TVs or head-mounted virtual-reality displays like Oculus Rift, you might want to take a look at this option.

Using Your GoPro
in the Water

GoPro cameras are ideal for underwater shooting, as long as you have the proper housing (specifically, the Standard Housing or Dive Housing).

Before you jump in, however, make sure you have the Standard Backdoor attached and not the Skeleton Backdoor (with holes in the side). You might also want to have a few other (optional) accessories on hand for your next aquatic expedition.

Anti-Fog Inserts

Although not exclusively for use in the water, Anti-Fog Inserts are designed to prevent your camera from fogging up in cold or humid environments. Add these strips to your camera's housing to avoid missing a great shot due to a hazy lens.

Red Dive Filter

If you're diving in blue saltwater or clear freshwater at depths of 15 to 70 feet (4½ to 21³⁄₁₀m), use a Red Dive Filter to add color correction for more vibrant footage.

Magenta Dive Filter

Likewise, if you're diving at depths of 15 to 70 feet (4½ to 21³⁄₁₀m) in water that ordinarily appears green on camera, add the Magenta Dive Filter for the clearest image.

Floaty Backdoor

I highly recommend getting the Floaty Backdoor if you decide to use your GoPro in the water. With it attached to your camera (via one of the removable doors), your camera should safely float if it's accidentally dropped or falls off a vehicle in the water.

Securing Your GoPro
with Camera Tethers

GoPros are designed for all your adventures, no matter where the spur of the moment takes you. However, the one thing you don't want to leave to chance is the security of your camera.

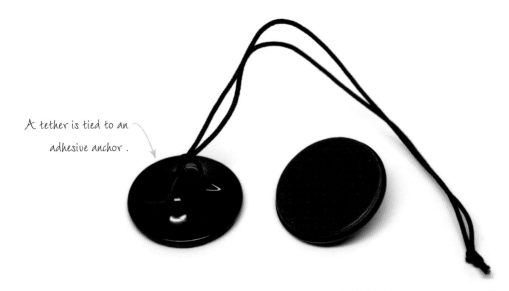

A tether is tied to an adhesive anchor.

A short tumble on the ground is bad enough, but dropping your camera in the ocean could mean an offering to Poseidon. It's therefore a good idea in any "extreme" scenario to utilize a camera tether to minimize the possibility of loss or damage should things go awry.

A camera tether is a piece of string (the tether) tied to an anchor that's fastened to a surface with adhesive, much like the other adhesive mounts GoPro sells. The tether is secured to the backdoor on your camera housing while the anchor is affixed to a surface, such as a helmet, kayak, or board. Camera tethers are sold in packs of five, although you might get some with other mounts you buy—for instance, the Surfboard Mount and Bodyboard Mount.

Leashes

If you're holding a GoPro using a stick or some other type of mobile mount, consider adding a leash that attaches to your wrist or arm, particularly if you're using it in the water. While The Handler (a floating hand grip mount) already has one, for other mounts, you can fashion your own with a piece of cord or purchase a more comfortable option from a third-party company.

Bags and Accessory Cases

How you store and transport your GoPro camera, as well as its accessories and mounts, is something you shouldn't overlook.

A good bag or case should protect the camera while organizing all of your gear. It should also be compact, ideally fitting in a backpack so traveling with it is easy—after all, if it's not easy to carry, you're less likely to bring it with you. GoPro's model, called Casey, has customizable dividers to hold several different accessories, mounts, batteries, cables, and multiple cameras. Its semi-rigid shell (a must-have for carrying gear) protects your equipment from being crushed.

Many other companies make cases as well, such as Thule and Pelican. While some are just rebranded cases for general use, others are specifically tailored to holding your GoPro kit. Custom foam inserts are a nice way to prevent your camera from rattling around in the bag, keeping it safe and accessible at the same time. Inserts with lighter colors (such as blue) make black GoPro pieces stand out by contrast, which means they're easier to find at a glance. Roll-up bags are also popular solutions for mobile shooters, offering quick access to accessories like Thumb Screws, miscellaneous mounts, and cables. Whichever bag or case solution you choose, I recommend having cable ties, zipper-lock bags, and a labeler to organize the pieces within.

THULE BACKPACK

This Thule-branded backpack includes a foam insert that lets you carry your GoPro camera and all of its accessories in a safe, secure manner.

Quick Release Buckles
and Thumb Screws

With cameras, as in life, it's often about having the right tool for the job. In the case of a GoPro, mounts and accessories may require special tools of their own to help you get the job done.

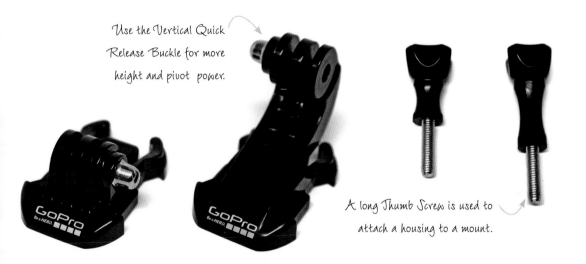

Use the Vertical Quick Release Buckle for more height and pivot power.

A long Thumb Screw is used to attach a housing to a mount.

Quick Release Buckle

In order to snap a GoPro into and out of different mounts, you'll need a Quick Release Buckle. This product comes in two types: the standard Quick Release Buckle (short) or the Vertical Quick Release Buckle (tall). The standard Quick Release Buckle is useful as a helmet mount or for anything that needs a lower mount setting. The Vertical Quick Release Buckle gives you the same range of motion as the standard, with the extra benefits of height and pivot for up-down and left-right angles.

Thumb Screws

Cameras are attached to the buckle via a Thumb Screw, which has a plastic handle of varying lengths (short and long) to accommodate different widths or heights of mounts and housings. The plastic handles on the Thumb Screws sold by GoPro are surprisingly tough; however, several companies sell versions with aluminum handles for especially rugged use. Plus, aluminum handles come in a variety of attention-grabbing colors for fashion-conscious users. So why not add a little color?

Miscellaneous Parts and Tools

As you've discovered, many parts go into making a GoPro camera operational, at least when you're using mounts and accessories. The following are some additional items beyond those you might find at the bottom of your toolkit.

The Tool

In high-wind or high-impact scenarios—such as surfing, skiing down a mountain, or driving with it attached to your vehicle—the Thumb Screw needs to stay absolutely secure without pivoting on its own. While you can tighten them by hand in most situations, The Tool, a Thumb Screw wrench (and bottle opener), is designed to tighten Thumb Screws as much as possible.

Attachment Keys and Rings

GoPro sells an Accessory Kit that contains attachment keys and rings for clipping your GoPro onto key chains, backpack zippers, lanyards, and more. The kit also includes a remote cradle for the Smart Remote and a wrist/pole strap.

Lens Replacement Kits

If the glass lens on your camera housing becomes scratched or cracked, you can replace it using one in the Lens Replacement Kit, which also comes with everything you need to do the simple repair. Kits typically include two replacement lenses, seals, screws, and a screwdriver. Lens Replacement Kits are currently available for the Standard, Skeleton, Blackout, Dive, and Wrist Housings; the Hero4 Session; and the Dual Hero System.

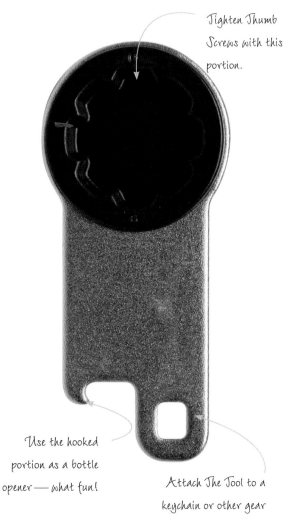

Tighten Thumb Screws with this portion.

Use the hooked portion as a bottle opener — what fun!

Attach The Tool to a keychain or other gear for quick access.

Cables and Adapters

Many cables and adapters help you connect video, audio, and power to your GoPro camera.

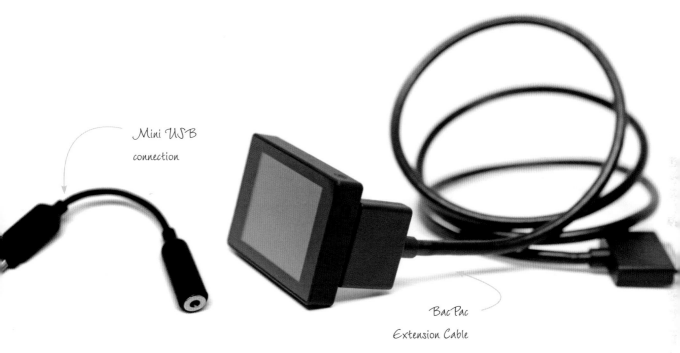

Mini USB connection

BacPac Extension Cable

For charging and data transfer, its Mini USB connection requires a cable with Mini USB at one end and a full-size USB at the other. A 3.5mm Mic Adapter, which can also be connected to the Mini USB port, allows you to use external microphones for better sound capture. Additionally, a special Combo Cable enables composite video output (for monitoring on older analog devices) and includes a 3.5mm microphone adapter and USB input. You can also purchase a Mini USB Composite Cable without USB or audio connections.

If you want the highest-quality video output, use a Micro HDMI to full-size HDMI cable (depending on your monitor) to connect to the Micro HDMI port. You can then play back your video on a big-screen HDTV. GoPro sells a cable just for this; however, it's 6 feet long (1.75m), so your camera will need to be fairly close to the screen when it's connected to it.

Another cable you might consider is the BacPac Extension Cable, which lets you connect your LCD Touch BacPac or Battery BacPac to the camera from a short distance. This cable helps you frame up shots when your camera is mounted on a pole or in an awkward position.

Chapter 5: Basic Shooting with a GoPro

It's easy to get so bogged down in thinking about accessories and mounts that you forget the best part about owning a GoPro—shooting video! Yes, underneath all those cases, mounts, and shiny accoutrements is a camera waiting to capture something exciting and fun. In order to get the best results, it's good to understand the general principles for shooting video and capturing audio, as well as for modifying your camera settings to obtain the images you want.

In Chapter 2, I discussed the basic steps to follow in order to shoot a quick video. In this chapter, you learn how to go a step further with your GoPro, including some tips for working with light, where to position your camera, and how to troubleshoot common hiccups.

Placing the Camera

Before you adjust specific settings, one of the most important choices you need to make is how to position the camera. Carefully consider the perspective you want to achieve, as well as the size of your subject within the frame.

High-angle shot

Low-angle shot

In terms of angles, high angles (looking down) make a subject appear smaller or more vulnerable, while low angles (looking up) make a subject appear larger or more powerful, with a perspective that looms above the viewer. With a GoPro's wide-angle lens, both of these angles can be quite exaggerated and even bizarre when shot extremely close up.

More generally, close-ups, medium shots, and long shots (wide shots) are used in most video productions. These shot types simply indicate the size of your subject in the frame. There's also the point-of-view shot, which is popular with GoPro users. A point-of-view shot simulates what subjects or participants are seeing, as though viewers are looking through their eyes or from their precise viewpoint. Usually this is accomplished with a Head Strap or even the Chesty, depending on the effect you're trying to achieve.

A GoPro mounted on your head creates a perspective that's surprisingly different than when it's mounted to your chest.

Choosing an **Effective Composition**

Composing a scene is what truly elevates your shots. You can have the best subject in the world and still have subpar images if you don't put thought into the way it should look.

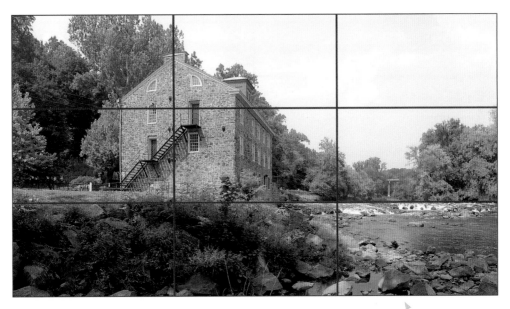

The rule of thirds in action.

One useful technique for composition is called the *rule of thirds*. Basically, you divide a frame into three vertical and three horizontal sections and place your subject along one (or a combination of) those lines. For example, when filming a landscape, you can place the horizon in the lower third (more sky) or upper third (more land) of the frame to create a pleasing composition. Photographers and videographers are also often taught to place their subjects toward one side of the frame or the other using the rule of thirds. However, with the wide-angle distortion on a GoPro, subjects may look their best in the middle of the frame.

Another composition option is to tilt the camera up or down, particularly when shooting close up. This can exaggerate proportions to dramatic effect, or level out your compositions to balance curvature. Finally, when composing a shot, it's best to reduce the amount of information in your shots, focusing on the important details of your scene. For example, place your subjects against simple backgrounds that don't distract from the foreground action.

Selecting the **Best Camera Mode and Capture Settings**

Once you've decided how you want to compose your shot, you can make some other setting adjustments to capture the best footage for your needs. The following are the most common things you'll adjust and are found under the basic Setup mode.

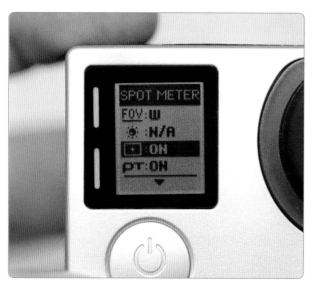

Spot Metering

Spot metering tells the camera to expose for the center of the frame, rather than the frame as a whole. This is useful when the thing you want to capture is very bright or very dark while the rest of the frame isn't, such as a backlit subject. By placing your subject in the middle of the frame and activating spot metering, you can sometimes get better results and a more usable exposure.

1. Press the Settings/Tag button on the side of your camera to enter the Settings menu.

2. Use the Power/Mode button to move down the list to the Spot Meter option. Press the Shutter/Select button to toggle it On or Off.

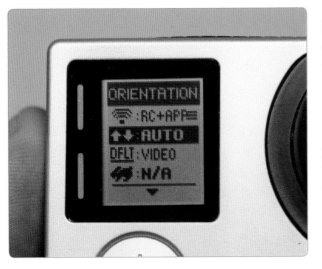

Upside-Down Shooting

You can use the Orientation setting to flip your camera's image, depending on how your GoPro is mounted.

1. Push the Power/Mode button until you see the Setup mode, and then press the Shutter/Select button.

2. Use the Power/Mode button to move down the list to the Orientation option (represented by the up-and-down arrow icons).

3. Press the Shutter/Select button to cycle through the choices of Up, Down, or Auto.

Looping Video

Looping Video (also available in the Settings menu) is an often-neglected feature that activates continuous recording, overwriting video that was already shot depending on the interval you set. This feature is great for dash cam work (which is discussed more in the dash cam project later in this book).

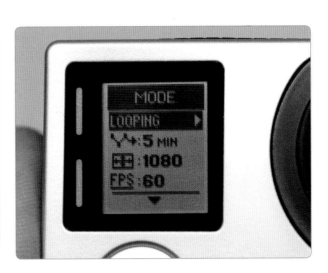

Working with **Protune**

Protune is a set of options accessed through the Settings menu that give you maximum control over image quality. It's here that professional users will find many of the features they require. If you won't be doing a lot of color correction, adding your video to a film project, or matching your camera to other devices (that is, if you'll just be shooting for fun), you don't have to worry too much about these controls. However, sometimes they may be the solution to a common image problem.

Adjusting Exposure Compensation

Exposure is the result of aperture (the size of a lens opening, where light enters), shutter speed, and ISO (the sensitivity of the sensor, or gain). Although a GoPro sets the exposure automatically, you can adjust it from -2.0 up to +2.0 in 0.5 increments in the Protune settings. Choose lower numbers (such as -1.0) when the automatic exposure is too bright and higher numbers (such as +1.0) when the exposure is too dark. A degree of experimentation will be necessary—start with small adjustments to avoid drastic errors in exposure, check the results, and readjust if necessary. However, always remember to reset it back to 0 once you've got the shot.

1. Press the Settings/Tag button on the side of your camera to enter the Settings menu.

2. Use the Power/Mode button to move down the list to the Protune option (PT). Press the Shutter/Select button to turn it On.

3. Press the Power/Mode button again to move down to EV Compensation.

4. Press the Shutter/Select button to adjust the exposure compensation value in increments of 0.5. Values start at 0 and then move downward to -0.5, -1.0, -1.5, and -2.0 before returning to the positive values of +2.0, +1.5, +1.0, and +0.5.

ND Filters

You can influence your camera's shutter speed by using a neutral density (ND) filter. An ND filter cuts down on the amount of light that enters the lens.

Choosing an ISO Limit

While you don't have control over a GoPro's aperture (fixed) or shutter speed (variable), you can adjust the ISO. A lower ISO number means less sensitivity to light, while a higher number means more sensitivity to light.

For the cleanest, sharpest images, set your ISO Limit to 400 in the Protune settings. In lower light, this will force your camera to use a slower shutter speed (which can be desirable in itself, since a little motion blur looks more "filmic"). If there isn't enough light for a decent exposure, you can increase it to 800 or 1600. However, be aware these higher ISOs (such as 3200 or 6400) can introduce a lot of image noise, meaning they can take away from the detail, sharpness, and vibrancy of color.

Adjusting Color Profiles and Sharpness

In conjunction with lighting, color profile and sharpness can affect the look of your image. You can change both in Protune. For color profile, keep it set to GoPro Color for most situations, or choose Flat if you're using advanced color-correction tools for professional results. For times when your image looks artificially sharp, consider reducing Sharpness from High to Low for smoother, more filmic results.

Setting White Balance

The color of light is measured in degrees Kelvin (K), such as 3000K (indoor, incandescent), 5500K (daylight), and 6500K (cool light or an overcast sky). In practical terms, this ranges from orange (3000K) to blue (5500K to 6500K). While our eyes compensate for the differences in color temperatures, naturally balancing it out, a camera needs someone to tell it what is true "white"—hence the White Balance feature on most cameras. To set the white balance on your GoPro, follow these steps.

1. Press the Settings/Tag button on the side of your camera to enter the Settings menu.

2. Use the Power/Mode button to move down the list to the Protune option (PT). Press the Shutter/Select button to turn it On.

3. Press the Power/Mode button again to move one spot down the list to the White Balance controls.

4. Press the Shutter/Select button to cycle through the available options of 3000K, 5500K, 6500K, Native, and Auto. Choose one of the fixed values or stick with Auto, which is the default (the camera chooses based on an analysis of the shot). Native is only an option if you have professional editing and color correction software to manipulate the white balance in post productions.

Audio Recording Fundamentals

If you're like many GoPro users, you may become so enamored by the amazing images your camera produces that audio quality becomes secondary. If you're planning to put music under the pictures—which many users do—it's not much of an issue. However, if you'd like to record audio while shooting, a few simple considerations can dramatically improve your results.

Choosing an Open Camera Housing

One very easy way to improve audio quality is to use the right housing. The best camera housings for audio (other than a naked GoPro) are The Frame and the Skeleton Housing. Unlike the Standard Housing, both of these have open designs that prevent sound from being muffled by the case.

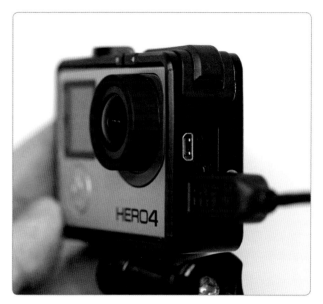

Maintaining the Proper Distance

As photographer and journalist Robert Capa once said, "If your photos aren't good enough, then you're not close enough." The same could be said about audio for many camera systems and microphones. Make sure you're near enough to your subject that the audio levels can dominate the soundtrack and drown out the background noise.

Identifying Noise Problems

Wind noise is a constant problem for cameras when shooting action, or even just outside on a blustery day. The Hero4 Session has two microphones—one facing forward and the other backward—that it switches between to get the best sound capture when wind is present. Other Hero4 cameras can use the optional WindSlayer foam windscreen to reduce the noise.

Other noise issues that affect your audio can be trickier to diagnose. Microphones can pick up interference from electrical power lines or HVAC around a building. Ever-present radio waves and mobile devices can also cause potential sound issues. And some defective models have even had problems with interference from the camera's own WiFi. However, no matter what you think could be causing the noise issues, the best solution is to turn off the offending source or to move to another location, if possible.

Using an External Microphone

GoPros adjust sound input automatically. However, with the exception of the Hero4 Session, even the best audio from a GoPro is still being produced by a tiny, inexpensive, and not-very-directional microphone hidden on the camera. Considering its limitations, this microphone does surprisingly well and is great for casual use. However, if you're shooting a short film, interviews, or any other projects that require high-quality audio, you should consider adding an external microphone to your arsenal. The following are a couple external microphone options:

- **Shotgun microphone:** This directional microphone is useful for general documentation and more precise sound capture purposes. While they can also be good for interviews, you must remain close to your subject in order to reduce noise.
- **Lavalier microphone:** This small microphone, which can be attached to a subject's shirt, is great for interviews.

In order to attach an external microphone to your camera, you need a GoPro-brand 3.5mm Mic Adapter. Because the adapter connects to the USB port on the side of your camera, make sure you're using only The Frame or the Skeleton Housing on your camera; only these housings allow you to access the port. And for directional shotgun microphones, consider using a flash bracket or cage system of some kind to hold both the camera and your microphone.

Chapter 6: Setting Up Your Editing System

Media management and high-quality output is best achieved with a computer. Using a computer running the latest (and free) GoPro Studio software or working with specialized editing applications—such as Adobe Premiere, Avid, Final Cut Pro, or DaVinci Resolve (to name a few)— should provide you optimal results. This chapter covers the minimum and recommended requirements for your computer, as well as how to download GoPro Studio and any other GoPro-related programs you may want or need.

Once you have your editing system set up, I discuss some basic editing concepts. Finally, for times when you're less concerned with quality and more concerned with immediate editing and sharing of your footage, I go over how to trim and share clips with your mobile phone and tablets using the GoPro app.

Minimum **System Requirements**

Because new and improved video formats are constantly appearing, the requirements for working with GoPro footage continue to change as well. GoPro's website (gopro.com) lists the latest specifications for GoPro Studio for both Mac and Windows. Currently, the minimum requirements listed by GoPro are as follows.

	MAC OSX 10.9 OR NEWER	WINDOWS 7, 8.X, OR 10
CPU	Intel Dual Core	Intel Core 2 Duo
Graphics Card	Any graphics card shipped with Intel Dual Core Macs or better	Graphics card that supports OpenGL 1.2 or later
Screen Resolution	1280 × 768	1280 × 800
RAM	4GB	4GB
Hard Drive	5400 RPM internal drive	5400 RPM internal drive
QuickTime	n/a	Version 7.6 or greater

Graphics Card Drivers

Whichever system you use, make sure the drivers for your graphics card (or GPU, the "Graphics Processing Unit") are up to date before you download and use GoPro Studio. Visit the manufacturer's website to get the latest in driver updates. On a Mac, you can run Software Update (found in the Apple menu drop-down list under "About this Mac"), which includes updates for the graphics driver. Windows users can use the DirectX Diagnostic Tool to determine the manufacturer and model of card they have by typing "dxdiag" into the search box found in their Start menu.

Recommended **System Requirements**

As the demands of 4K, high-frame-rate video increase, so, too, will the systems necessary to edit them.

For example, a faster CPU will speed up the conversion process and rendering of effects. If you're working with a large amount of material or longer clips, the benefits of a more powerful CPU are obvious. Also, a faster hard drive will help you to read and write large files more quickly, which is particularly important when editing with 4K video formats. An SSD is the fastest and most reliable of all drives, because it uses flash memory without spinning platters. However, if you're storing a lot of video files, you can get much more capacity at a better price with a traditional spinning hard drive (HDD). If you decide to use a drive that spins, choose one that operates at 7200 RPM for speedier results.

Although you can run GoPro Studio software and edit GoPro camera footage on slower machines, performance will degrade—sometimes considerably, depending on the formats you're working with. The computer specifications listed in the table are recommended by GoPro.

	MAC OSX 10.9 OR NEWER	WINDOWS 7, 8.X, OR 10
CPU	Intel Quad Core i7 or better	Intel Quad Core i7 or better
Graphics Card	Intel HD4000 or better	Intel HD4000 or better (or similar class graphics card)
Screen Resolution	1280 × 768	1280 × 800
RAM	4GB	4GB
Hard Drive	7200 RPM drive or SSD	7200 RPM drive or SSD
QuickTime	n/a	Version 7.6 or greater

RAM

While 4GB is all that's required, consider increasing your RAM if you can afford it. An upgrade to 8GB or 16GB is particularly nice if you plan to do any multitasking while working in GoPro Studio.

Monitors and Hard Drives

Properly viewing your footage as you edit can have an effect on the final image results—plus, it's good for morale to see your footage looking its best.

Calibration, size, and resolution are key when it comes to judging whether a particular monitor will work well for editing. A manually calibrated monitor (contrast, brightness, and color, for example) will help you make better color correction decisions. In terms of size, you'll inevitably work faster if the screen is large enough to show more clips or to provide access to multiple file windows. Typically, a monitor of 27 to 32 inches (68.5 to 81cm) is the smallest you'd want to work with for 4K imagery. In terms of resolution, it should preferably have a refresh rate of at least 60Hz when connected to your computer for smoother output and less motion blur. Whether you can achieve 60Hz output from your computer depends on your computer's video card, available HDMI or DisplayPort connections, and the monitor's ability to support them. For example, a DisplayPort 1.2a (and higher) or HDMI 2.0 connection are required for 4K, 60Hz connections—if supported by your computer.

In addition to a good display, consider adding one or multiple extra hard drives to store and back up your files. You want to have at least two copies of all your media on separate drives—and, ideally, in separate locations. This provides you a level of security in case one hard drive gets lost, stolen, or damaged. Also, a RAID (with multiple discs) or an SSD will speed up playback and file transfers. Depending on the configuration, a RAID may also provide safer storage if set up as a RAID 1, RAID 5, and up. Just remember to back up and save separate copies of your files.

Speakers

In order to properly evaluate sound levels for your projects, it's best to use external speakers or headphones rather than your computer's built-in speakers. Keep in mind that, even more so than displays, different speakers will have their own unique properties. Sound quality varies widely. While most consumer speakers and headphones are designed to sound good out of the box, professional mixers will want speakers that are more natural sounding and unbiased toward the high, low, or mid ends of the audio spectrum.

Card Readers and Adapters for
Transferring Files

To transfer footage from your camera to your computer, you can either plug your camera into a Mini USB cable or—as I'll discuss here—eject the camera's MicroSD card, insert it into an adapter, and use a card reader. The card reader may be a slot built into the side of your computer, or it may be a separate device attached to your computer via USB. While some card readers will accept MicroSD cards directly, it's more likely you'll need to use a MicroSD card adapter to load the card. Fortunately, most MicroSD cards come with this adapter.

When you're ready to use the card reader, carefully load your card inside. (Avoid touching the metal contacts, as these can corrode over time.) Once your card is mounted on your computer, I recommend you copy the files from your card into a folder on your hard drive. That way, you'll import media into GoPro Studio from this location, rather than directly from the card. Doing this means you're less likely to lose important files and gets footage ready for backup. When the transfer is complete, eject your card.

Erasing Media from a Card

If you've backed everything up and want to erase media from the card (otherwise known as *reformatting*), don't do so on your computer. Instead, load the card back into your GoPro and reformat it there. Doing so ensures the card's file format and folder structure are set up properly for use with a GoPro camera. The option to reformat a card can be found in the Setup mode under the Delete option (which is shown as a trash can icon).

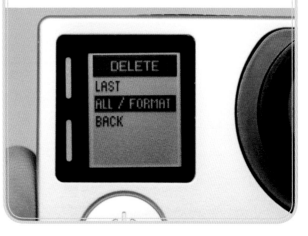

Downloading and Installing **GoPro Studio Software**

In order to edit your footage, you'll want to download and install the free GoPro Studio software. The following steps walk you through the process; I've used the Mac in this example.

1. Visit the GoPro website: gopro.com. Click Products > Software & App > GoPro Studio.

2. At the bottom of the page, choose your operating system from the drop-down menu and enter your email address. Click Download Now.

3. Once it's finished downloading, double-click the disk image icon to access the installer.

4. Double-click GoPro Studio.pkg to launch the installer. The Install GoPro Studio installer window should appear.

5. Click Continue to progress through the installation steps, checking the latest system requirements along the way. Click Close when the installation is complete.

6. When you've finished installing the software, GoPro Studio should appear in your Applications folder.

Installing Additional
GoPro-Related Software

In addition to installing GoPro Studio software, you may want to update your camera's firmware, as well as install the GP Training app.

GoPro Firmware Updates

GoPro issues firmware updates to fix problems or offer new features. Visit gopro.com/update, or look for Camera Software Updates at the bottom of the GoPro website to check for new releases.

GP Training App

In Chapter 2, I discussed how to install the mobile GoPro app, which is an essential download for your iOS or Android device. In addition, you may want to install the official GP Training App. While not essential, this app is useful for learning about the latest GoPro products. Simply search "GP Training App" in your phone's app store to find the download.

You can install these updates through the GoPro Studio software by using the GoPro app or by following the step-by-step process outlined on the GoPro website.

What's Coming Up

GoPro recently acquired Kolor, which specializes in panoramic imagery solutions, including panorama, virtual tour, and video stitching software. Combined with GoPro working on drones, this is an exciting time to keep an eye out for future apps, products, and software offered by the company.

Approaches to **Editing GoPro Videos**

While you can treat GoPro footage as though it came from any other camera (and it's effective in many cases), that's often missing the point. Most footage shot with these cameras screams "GoPro" anyway, so why not embrace it? The following are some things to consider when editing GoPro videos.

Using the Right Editing Tools

Before you begin editing, consider your choice of tools. If you're editing short pieces with mostly GoPro footage, GoPro Studio is a good option, and the discussions in this chapter pertain almost exclusively to using GoPro Studio. For larger projects, however, more advanced software (such as Adobe Premiere and DaVinci Resolve) will allow you to better organize footage into bins (folders), trim clips more precisely, and sync audio with confidence.

Editing: Not Just Cutting Out the Bad Bits

Many people see the process of editing as simply cutting out the bad bits. However, editing involves looking beyond good versus bad. In some cases, it's often a matter of selecting the best take and cutting it down to a palatable size, like watching particularly good ski slalom or surfing point-of-view footage. In most other cases, editing requires deliberate stylistic approaches using multiple shot types.

Choosing an Appropriate Style

When it comes to editing your footage, you want a style that includes a diversity of voyeuristic pleasures. A traditional—and still effective—approach is to construct a sequence out of wide shots, medium shots, and close-ups. Wide shots are used to establish a scene or give context to broad actions, like a ski jumper leaving the ramp or a car passing by on the road as seen from the sidelines. From there, you could cut to a point-of-view shot, followed by a close-up facing the skier's face mask or the driver in his seat. Experiment with the order and type of shots (sizes and perspectives) to create different styles.

From left to right: wide, close-up, and medium shots.

Basic **Editing Techniques**

While you can use many interesting editing techniques, the following discussion pertains primarily to things you can accomplish in the current version of GoPro Studio.

Establishing Shot Length

Deciding on how long to hold a shot will depend on the approach you've chosen, as well as your content. If you're cutting to fast-paced music or almost anything with a rhythm, quicker cuts are the norm. However, sometimes not cutting is a choice that can give your shots more power. For example, skydiving clips are usually best when you get to experience the full ride. Determine a tempo that feels right for your piece. In general, shot lengths of 2 to 10 seconds are common, with most landing in the 2- to 5-second range. Again, it's not an either/or proposition (Michael Bay or Tarkovsky), so just go with the flow.

Fades and Dissolves

Fades and dissolves are transitions that can communicate a change in time or place, as well as smoothly carry a viewer into or out of a scene. While it's best not to overuse these effects, the beginning and end of a piece are almost always good spots to use a fade in or fade out.

Slow Motion

Slow-motion shots can add drama or poetry to a piece. It extends a moment, potentially highlighting an action, which is useful for some GoPro videos. Use slow motion selectively to heighten the effect. While you can (and should) try shooting slow motion in the camera, the Flux option in GoPro Studio can slow down your footage even further.

Match and Jump Cuts

When cutting action shots together, particularly from multiple viewpoints, an effective technique is to perfectly align the movements and actions between shots, creating continuity. These match cuts make the action feel continuous or uninterrupted.

When dealing with a single point-of-view shot (for example, a camera mounted on your head or chest), use of the jump cut is almost expected. Jump cuts are when two sequential shots from the same (or roughly the same) camera position are cut together, creating the sensation of jumping ahead in time. It's a good way to condense events while adding a kind of energy.

Using Video Trim and Share with **the GoPro App**

Using the GoPro app on iOS or Android, you can quickly and easily trim and share a clip online. Using this feature means you don't have to wait until you get home to edit and share clips. Just make sure your camera is up to date with the latest software before you begin this process and that the resolution of your original clips is supported by your phone and the app (video shot in 1080p at 30 fps or less is widely supported).

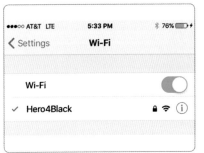

1. Connect your camera to the GoPro app using WiFi.

2. Select and play back the video that contains the clip you want to share.

3. As you watch the video, tap the scissors icon when you reach a moment to share. A portion of the clip will automatically be selected. (The GoPro app's default is 15 seconds; however, you can choose 5- or 30-second durations as well.)

Using Your LCD for Trimming

You can also trim video on your camera if you have a built-in LCD screen or LCD Touch BacPac. Simply play back the clip you want to trim, pause it, and press the scissors icon. By default, clip portions are 5 seconds instead of 15. Tap the plus or minus buttons to adjust the start and end points of a clip, and then tap Save. Clips are saved as new clips to be shared later on the GoPro app or with GoPro Studio. However, you can connect to the GoPro app at any time to select and share them.

4. Play back the clip to make sure the correct portion is highlighted. If you'd like to adjust the start or end point, click and drag the frame left or right; the duration of the clip will remain the same.

5. When you're done trimming, tap Next to proceed.

6. On the screen that follows, tap the icon for Facebook, YouTube, or Instagram to share your clip.

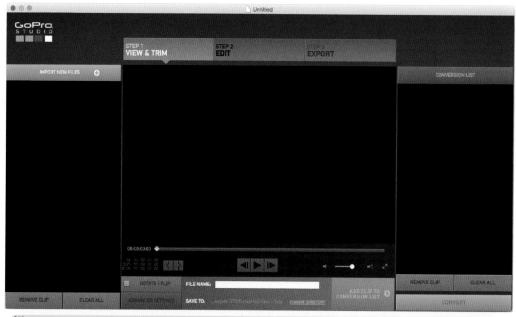

Chapter 7: Editing with GoPro Studio

Shooting videos with your GoPro is great, but eventually you'll want to show them to someone. Unless you're uploading individual, raw clips without additional trimming or manipulation, this means you'll require software to edit your videos.

The free GoPro Studio software, which you downloaded and installed in the previous chapter, is a quick and easy solution for editing your GoPro videos into a polished piece. While even experienced editors may be initially confused by its unique layout and limited (though useful) feature set, most of its features are rather intuitive. The workflow is also a bit simplified and proprietary, as compared with other editing software. Overall, it offers a quick and easy way to get video in and out in a dash, leaving aside features that typical GoPro users won't miss. This chapter walks you through the basic GoPro Studio workflow.

Understanding the
GoPro Studio Workflow

GoPro Studio software greatly simplifies the process of creating a finished project from your footage. The workflow is broken down into three easy steps, which are listed on tabs along the top of the GoPro Studio interface. Simply follow each of the steps, progressing from one tab to the next. Along the way, you'll encounter additional opportunities to refine and enhance your final content with more advanced options.

Step 1: View & Trim (Import & Convert)

In this tab, you can import any footage you want to work with in GoPro Studio and convert it to the GoPro CineForm format for use in the editing process. By converting your selected clips from the highly compressed format your camera shoots to a less compressed format like GoPro CineForm, your computer is better able to process and play back the footage. This makes it easier for your computer to decode and offers better image quality throughout the ensuing editing and color correction process. At this stage, you can also preview your clips and select the best shots—or trim to use only the best portions of your shots—which saves you a lot of time later on.

Saving Space

Previewing and trimming clips also saves space on your hard drive, because any clips you convert will take up additional space on your computer.

Step 2: Edit

Using the clips you've imported, the next step is editing your content into a finished piece. This includes adding any text or effects to your video. It's also the stage where you get to have the most fun. Seeing your projects come together with each new decision you make is very satisfying. Adding and deleting clips, trimming in and out points, and generally refining the vision for your movie are all part of the editing process. The most difficult part is not obsessing too much over the details. GoPro Studio provides only the most basic editing tools you might need, which keeps everything moving along.

Step 3: Export

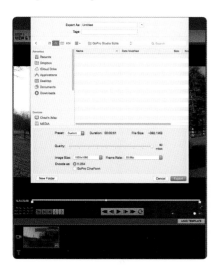

Once you've finished editing your video, it's time to export and share it with the world. You can choose from a variety of export options, including YouTube, Vimeo, and GoPro's high-quality CineForm codec. This is also a good time to think about backing up your project files. At the very least, you can export a CineForm copy for re-encoding later on or for incorporating into another video edit (such as a highlight reel of your best GoPro videos).

Full-Screen Interface

By default, the interface floats in the middle of your screen. Changing your View to Enter Full Screen can be done from the menu bar at the top of the screen. You can also click and drag the edges of the main interface to make it bigger or smaller.

Adjusting **GoPro Studio Preferences**

GoPro Studio has a few preferences that primarily affect the way it imports media. To access these items, click the GoPro Studio drop-drown list and choose Preferences. The following goes over each of the preferences you can alter.

Use Time of Day for Timecode

Use Time of Day for Timecode reads the time-of-day information from your original video file (when you recorded it) and writes it to the timecode track on the files you convert. As long as you remembered to properly set the date and time on your camera, you can leave this option checked.

Use Reel Name in Destination

Use Reel Name in Destination automatically adds names to converted files. By default, this option appends the name of the folder you imported the clips from (on your hard drive or GoPro) to the front of those clips. For example, if you imported the clips from a folder called "Tuesday," it would name files "Tuesday_GOPR2550," and so on.

Auto-Start Conversions

Auto-Start Conversions tells GoPro Studio to automatically start converting files when they're added to the conversion list, instead of waiting for manual instructions. If you don't often remove files from the list, feel free to keep this checked.

Automatically Import from GoPro Cameras

Automatically Import from GoPro Cameras detects your GoPro camera when it's connected to your computer and automatically imports files from it. It's best to leave this unchecked and import manually to control the amount of storage space you use.

AutoSave Options

AutoSave automatically saves your project at predefined intervals, ranging from 30 seconds (½ in the Preferences menu) to 60 minutes. While you can turn this option off, I recommend you leave it on. That way, you'll be covered in case your computer or software crashes while working or there's a loss of power.

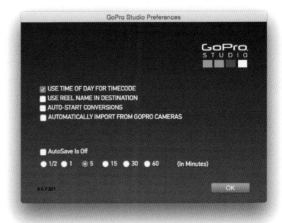

Creating a **New Project**

With your preferences set, it's time to create your first project! To start, it's a good idea to first save and name your new project. This is something you need to do eventually anyway, and doing it early makes incremental saves much easier via keyboard shortcuts (Command+S on a Mac and Ctrl+S on a PC) or the Project Auto Save feature.

1. Launch GoPro Studio by clicking its application icon or shortcut.

2. Click File > Save Project. Name your project and select a location on your computer to store it. Click Save to continue.

3. Click File > Project Auto Save and select how often you want GoPro Studio to automatically save your project. I recommend selecting every 5 minutes; however, if you have a slower machine, one of the higher options is better. You can also set it to Off and save manually, if you trust yourself to remember.

GoPro Project Folder

While the screenshot for step 2 shows a project being saved to the desktop, consider creating a folder where you can store all of your GoPro project files. This will make keeping track of them much easier.

Importing **Media**

When you're ready to start working with the footage you've shot, you can transfer it to your computer directly from the camera or its memory card. However, before importing the footage into GoPro Studio, you may want to copy the media from your card into a separate folder on your hard drive. While this step isn't necessary, it adds a level of protection in case the data on your card is accidentally deleted or damaged. Also, it's a first step toward long-term storage options for backing up your media.

Importing Video or Photos

The first step to working with footage in GoPro Studio is to import the files. The following steps show you how.

1. Click the blue Import New Files button on the left side of the screen. An Open file window should appear.

2. Select videos or individual photos you want to import. You can select multiple files by holding down the Shift or Command key on a Mac and the Ctrl key on a PC. Entire folders can be imported as well simply by selecting them as you would individual files.

3. Click Open to bring the files into GoPro Studio.

Removing a Clip

If you change your mind and want to remove a clip from your project, simply select it from the list on the left and click Remove Clip. To remove all of the listed items, click Clear All. Neither of these options deletes any of your original footage; they just remove them from your current project.

Importing a Time-Lapse Sequence

A time-lapse sequence consists of many sequential still photos that can be compiled into a single video file using GoPro Studio. When using the Time Lapse Video function on your GoPro, this happens at the time it's recorded in the camera, greatly simplifying the process. However, if you use the traditional Time Lapse option in the Multi-Shot mode, individual photos are produced, meaning you need to import using the following steps.

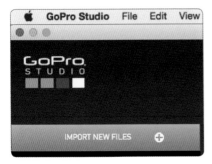

1. Click the blue Import New Files button on the left side of the screen. An Open file window should appear.

2. Select a folder that contains the time-lapse sequence you want to import (such as a folder with a sequence of night-lapse images). Make sure you select the root level of the folder and not an individual image.

3. Click Open. The photos in the folder you selected are automatically compiled into a video clip upon import.

Viewing **Clips**

After you import your files, the next step is to view and choose the clips you want to use. In GoPro Studio, information about each clip is shown on its thumbnail view, such as its resolution and frame rate, duration, and 2D or 3D property. A small icon below each thumbnail also indicates whether the clip is a video, photo, or an image sequence.

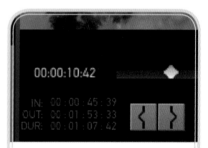

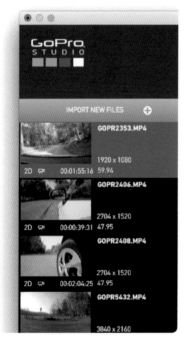

1. Click on a clip in the Media Bin to select it. The clip should open in the viewer window in the middle of the GoPro Studio interface.

2. Press the Play/Pause button to preview the clip, or use Spacebar on your keyboard to start and stop playback. You can quickly scroll through a clip by dragging the playhead.

Timecodes

The timecode for your clip is displayed in the lower-left corner of the viewer window. Reading from right to left, a timecode is written in frames, seconds, minutes, and hours. From top to bottom, it indicates exactly where the playhead is currently located in the clip, the duration, and the position of any in and out points (discussed later in this chapter).

JKL Playback Controls

Most video editing software offers the use of the adjacent J, K, and L keys for playback control. Pressing the J key plays your media in reverse, the K key stops playback, and the L key plays your media forward. Using these keys puts your hand in position to use other shortcuts as well, like the I (in point) and O (out point) keys immediately above. It also frees your other hand to use the mouse. However, keep in mind that pressing keys too quickly may cause a lag in playback.

ROTATE / FLIP ☑

3. Use the Step to previous frame and Step to next frame arrows to reverse or advance one frame at a time. (Alternately, use the left arrow and right arrow keys on your keyboard to do the same.)

4. If your camera wasn't set to automatic orientation (or if it wasn't set correctly), you can rotate and flip your clips at this time by checking the Rotate/Flip checkbox.

Trimming Clips

Aside from selecting the media to use in your project, deciding where to begin and end a clip is the most important editing decision you'll make. Trimming a clip ensures that only the portion you want to work with is added to your project. Making these decisions in the View & Trim stage of the process simplifies editing later on. And because it reduces the file sizes of clips, allowing only the portion identified by in and out points to be converted saves space on your hard drive.

Trimming Clips Using In and Out Points

Mark In

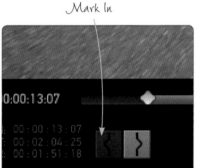

Mark Out

> ### Changing the Points
>
> Feel free to change the in or out points at any time while viewing a clip.

1. Determine the exact frame where you want your clip to begin and drag your playhead to that point. Press the Mark In button. (Alternately, you can use the keyboard shortcut I.)

2. Continue playing your clip, advancing frame by frame as you approach the exact frame you want to end on, and click the Mark Out button. (Alternately, you can use the keyboard shortcut O.)

Converting Clips for Editing

Once you've identified the footage you want to use and placed in and out points, it's time to convert your media for editing. The conversion process creates new files that are better suited to the rigors of editing and output.

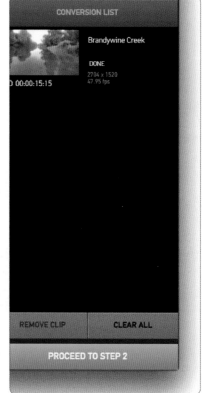

FILE NAME: Brandywine Creek

1. In the File Name box at the bottom of the View & Trim window, type a more descriptive name for the file you've selected.

2. Confirm the Save To location beneath the File Name—this is where your converted media will be stored. If necessary, choose a different folder on your hard drive by clicking the Change Directory link. Just make sure there's plenty of space in the directory you've chosen.

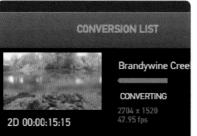

ADD CLIP TO CONVERSION LIST ▶

3. Click Add Clip to Conversion List. This adds files to a queue (called the Conversion List) to await final confirmation.

4. Click Convert to initiate the conversion process. The conversion process can take a while, particularly if you have a lot of long clips.

5. Click the Proceed to Step 2 button that appears after the conversion process has finished.

Choosing **Advanced Settings**

Although the Advanced Settings are optional, because they affect the basic quality of your video, you should become familiar with them. You can use them to counteract or enhance certain features of your footage, such as removing fisheye, changing speed, and more.

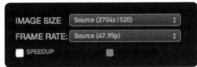

1. With a clip selected, click the Advanced Settings button in the lower-left corner of the View & Trim window.

2. Change Image Size or Frame Rate depending on your desired output, or simply leave it set to your current clip (Source) settings. If your final delivery format is less than the original image size, you could save a bit of hard drive space by changing it before the conversion process. Otherwise, you can always output a different size later on during the export step.

3. Check the Speedup option if you want to make a clip faster; this option is great for adjusting footage originally shot using slow motion or for a hyper, fast-forward motion up to 1,000×. While checking Motion Blur is optional when speeding up footage, it can make the motion appear more natural.

High vs. Low

If you'll be doing a lot of color correction and visual manipulation, even standard footage could benefit from a Quality setting of High. The advantage to choosing a lower setting is primarily in the amount of space the converted files will take up on your hard drive.

4. For best results, adjust the Quality setting (essentially, the bit rate) to High, particularly if your footage was shot using Protune. Video captured with Protune enabled utilizes a higher bit rate (more data for better quality), which you can carry through to the converted files in GoPro Studio using these settings. By default, it's set to Medium; this is fine for most footage, especially if it was shot using standard settings (in other words, not Protune).

5. Check the Remove Fisheye box if you want to reduce distortion caused by GoPro's wide-angle lens. However, doing so also reduces the field of view (FOV) by undistorting and cropping the image, creating an apparent zoomed-in effect.

6. Check the Remember settings for future clips box if you'll be using these same settings for multiple clips in your project.

Working with **GoPro Edit Templates**

GoPro Edit Templates are one of the features that differentiate GoPro Studio from other editing software. If you'd rather spend more time hiking or surfing and less time sitting in front of a computer, you can use one of GoPro's premade templates based on some of their most popular projects. These templates have placeholder footage and predetermined settings; this provides you with a tidy Storyboard timeline and a guide for shooting your own footage. At the very least, the templates offer great examples to learn about editing.

Loading a GoPro Edit Template

1. In the lower-right corner of the Edit window, click the Load Template button.

2. Choose a GoPro Edit Template based on your project needs and number of cuts. You can also obtain more templates by clicking the Download more GoPro Edit Templates here link. Click Create to load your selected template. It may take a few moments to optimize the media before it's ready to use.

3. Drag and drop footage onto the pre-existing clips in the Storyboard (also known as a timeline). Continue adding video and audio to fill out your Storyboard.

Understanding GoPro Edit Template Elements

While these templates are straightforward, let's look at the individual elements that make them up, as each element has its own functions and limitations.

GoPro Bumper: The first element you'll encounter is the inescapable GoPro Bumper, containing the image of a GoPro camera and the famous "Be A Hero" tagline, along with a dramatic sound effect. No doubt you've seen this used on countless GoPro videos online. This is an optional element, which means you can remove it.

Target Area and Optional Target Area: Signified by a bull's-eye, Target Areas are where you can drag and drop your own footage. These clips can only be replaced. However, Optional Target Areas, which appear as blank Optional clips, allow you to either replace or delete them.

Working with Blank Templates

If you'd rather create your own edits from scratch, you can choose the Blank Template option, which provides you with an empty Storyboard. It's likely most of your editing will be done with blank templates, as they offer the most flexibility. If you've used iMovie or other entry-level editing software, you'll have no problem with blank templates.

Music Soundtrack and Titles: The Music Soundtrack is the soundtrack included with the GoPro Edit Template. It's locked down and can't be moved or deleted. Titles, on the other hand, can be moved and deleted and have its text replaced.

1. Click the Load Template button.

2. Choose Blank Template and click Create.

3. Drag and drop clips onto the empty Storyboard.

Adding Clips to the Storyboard

You can add more media, such as previously converted clips or audio files, using the Media button at the top of the Media Bin on the left side of the GoPro Studio interface.

1. Click the Media button.

Adding Multiple Clips at Once

Select multiple clips in the Media Bin by holding down the Shift key on your keyboard or using Command (Mac) or Ctrl (PC) to select nonsequential clips. Drag and drop them onto the Storyboard and watch them appear sequentially. This is a quick way to add several clips to your Storyboard at once, based on their file name and the order in which they appear in your Media Bin.

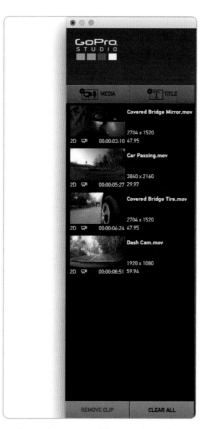

2. In the Open file window that appears, select the clips you want to import and click Open. Your new clips will appear in the Media Bin on the left. Notice how each clip has a duration, frame rate, and other information listed on its thumbnail.

3. Drag and drop a single clip from the Media Bin onto the Storyboard.

Previewing Clips in the Storyboard

In the same way you viewed and trimmed clips before converting them in the View & Trim window, you can view clips or the entire Storyboard using the playback controls in the Edit window. A few more options are available to you at this point in the process, based on needs specific to the Storyboard.

1. Click on a clip in the Storyboard to select it. Notice how the selected clip is highlighted yellow and opens in the viewer window.

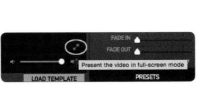

2. Click the Full-Screen Mode button in the lower-right corner of the viewer window to see your clips in more detail (press Esc to exit).

3. Press the Play/Pause button, Spacebar, or JKL keys to control playback. Activate the Loop button to continuously loop playback, if desired.

Step to previous frame

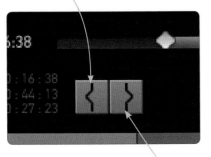

Step to next frame

4. Use the Step to previous frame and Step to next frame buttons, or the left arrow and right arrow keys, to reverse or advance one frame at a time.

Jumping Between Edit Points

To easily jump between edit points, hold down the Option key and press the left arrow or right arrow on your keyboard.

Moving, Deleting, and Trimming Clips in the Storyboard

Once you've added clips to the Storyboard, you can start the real work of editing—arranging, removing, and trimming your clips.

Rearranging and Removing Clips

It's easy to change the order of clips once they're in your Storyboard.

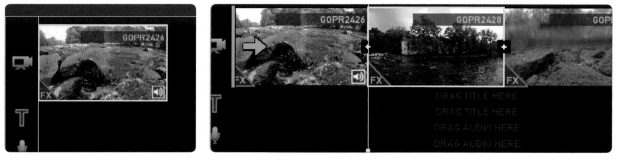

1. Click a clip in the Storyboard to select it (it should be highlighted yellow).

2a. To rearrange clips, click and drag a clip in between existing clips, or move it to the beginning or end of your Storyboard sequence. As you drag the clip using your mouse, a green arrow with a bar will indicate the eventual location and direction of your clip. The clip doesn't actually move until you let go of the mouse button.

2b. To delete a clip, select it and press the Delete key on your keyboard.

Undoing Changes

If you make a mistake while working with your clips, simply press Edit > Undo or use the keyboard shortcut Command+Z (Mac) or Ctrl+Z (PC) to go back a step or more in the process.

Trimming Clips in the Storyboard

Any clip you import needs either a little or a lot of trimming to make it work for a compelling edit. Trimming individual clips also affects the overall pacing of the entire Storyboard (which makes editing in the Storyboard different than the View & Trim step), so make your edit decisions with that in mind.

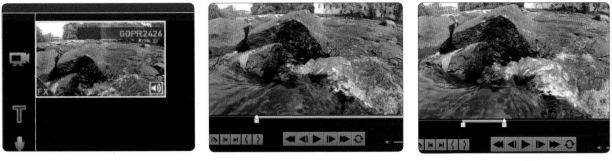

1. Click a clip in the Storyboard to select it and display it in the viewer window.

2. Use the playback controls to locate a good starting frame for the clip, and press the Mark In button (or the I key) to set a new in point. This automatically trims the top of the clip.

3. Navigate to where you want to trim the end of the clip and press the Mark Out button (or the O key) to set a new out point. This automatically trims the tail of the clip.

4. Play back portions of the clips before and after each new edit point in the Storyboard to test out the results and make modifications where necessary. You can place in and out points on the fly during playback as well using the I and O keyboard shortcuts.

Rejoining Videos Split by GoPro

You may have found when recording longer videos that your camera splits them up into smaller segments. This is done for a few reasons, including compatibility purposes and the file system limitations on your memory card. However, because the camera isn't stopping and starting recording when making these segments, you can rejoin the segments in GoPro Studio without seeing any breaks in action.

Modifying Color in Video Clips

Very few clips are perfect as you shoot them due to variations in lighting, color, and other attributes. Fortunately, GoPro Studio has several options for modifying the white balance, image properties (such as exposure and contrast), and more to fine tune your footage. You can access these controls through the menus on the right side of the GoPro Studio interface.

Changing the White Balance

One of the first color corrections you should make is modifying the white balance of your footage. For example, if your footage is too blue, too orange, or too magenta, you can correct it with these controls. Likewise, you can alter footage from one clip to better match another by either warming it up (orange) or adding a cooler look (blue). You can even make drastic color shifts for a special effect. To start, click on a clip to select it, and then click the arrow next to its White Balance option to see the different settings.

PREVIEW CHANGES
Check or uncheck the box next to White Balance to preview the clip with and without the new changes.

WHITE BALANCE
Click the eyedropper tool next to White Balance. Click on a color in your video that corresponds to (or should be) pure white. For many videos, this may be the only correction that's required.

TEMPERATURE
Drag the Temperature slider to the left (toward blue) to make the image appear cooler, or drag it right (toward orange and red) to make the image appear warmer.

TINT
Use the Tint slider to overlay a color on your footage or to make additional corrections.

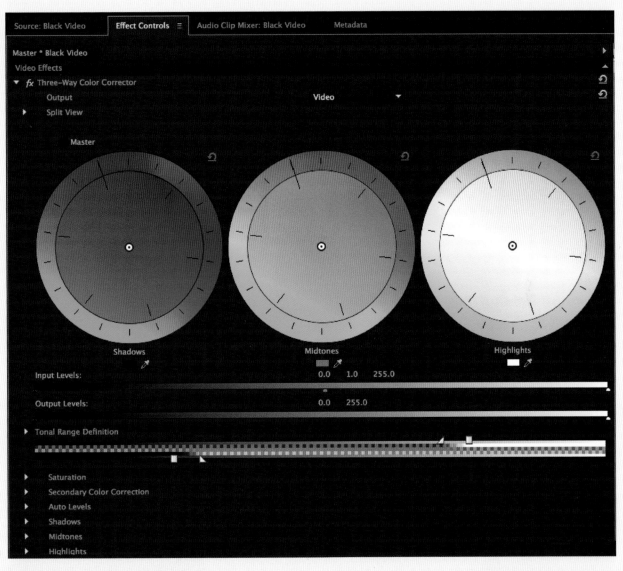

Color Correction Software

While GoPro Studio offers basic color correction options that should suffice for most users, professional and serious hobbyists will want to consider software that allows for finer control and more advanced features. One option is the free download of DaVinci Resolve. It includes video scopes and other tools that help you accurately judge color, as well as numerous options for looks that can be saved and applied to multiple clips. Most editing software, like Adobe Premiere, Avid, and Final Cut Pro, include advanced color correction options as well.

ADOBE PREMIERE

In this program, you can click and drag the middle of each color wheel to adjust shadows, midtones, and highlights, among other color adjustments.

Changing Composition with
Framing Controls

Framing controls allow you to adjust the size (Zoom), angle (Rotation), and position (Horizontal and Vertical). For example, to fix a crooked horizon, you can use Rotation, followed by Zoom to fill empty edges of the frame. You can also flip footage with an incorrect orientation, as well as change or animate certain portions using keyframes.

Adjusting the Framing of 4:3 Footage

Any footage shot in 4:3 modes—such as 960p, 1440p, or 2.7K 4:3—won't fill the frame on a 16:9 screen. For this reason, you can use Framing controls to make it fit.

1. Use the Zoom control to scale up the clip until it fills edges of the 16:9 frame.

2. Adjust the Vertical property until the portion of the clip you want to view is visible.

3. If necessary, use the Flip controls to flip the image in the Horizontal or Vertical direction. This most often needs to happen after shooting with the camera mounted in an upside-down position.

Working with Keyframes

Keyframes allow you to change or animate properties of a clip over time. In the case of GoPro Studio, you can make precise changes that affect a series of frames within a clip, rather than the entire clip as a whole, compensating for shifts in contrast and exposure, rotation, zoom (scale), and other properties.

1. Move the playhead to a frame in your video where you want to place the first keyframe, such as where you want to start a zoom or a particular Tint color. Use the plus button (located within the White Balance, Image, and Framing controls) to add a keyframe, and then make your adjustments to the clip's properties. In this example, I changed the Tint color to red.

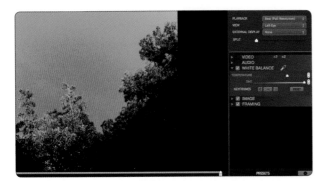

2. Move the playhead farther along in the clip to the point where you want to stop animating a property, such as where you want to stop zooming or change to a different Tint color. Click the plus button again to add another keyframe and change the property you want to modify. In this example, I changed the Tint color to green.

3. Follow the previous steps to add more keyframes if desired. Play back your clip and notice the changes that occur over time with the keyframes.

H.Zoom and H.Dynamic

Alternately, you can use H.Zoom (simple stretching) or H.Dynamic (dynamic stretching) to stretch video. These controls help the footage fill the frame without requiring zooming or repositioning, much like the SuperView modes on your camera.

Applying **Presets and Effects**

GoPro Studio includes a variety of Presets that automatically apply dramatic color changes (1970s and Candy Color looks, for example), special effects (such as Day for Night or Night Vision), and more. These quick and easy looks are ones like you might find in a photo sharing app.

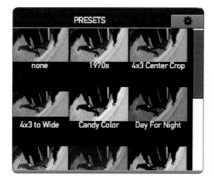

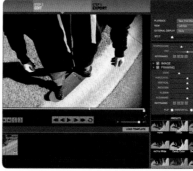

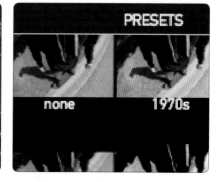

1. Select a clip in the Storyboard and look at the Presets window. This shows you thumbnail previews of the various effects you can apply to the clip.

2. Click on one of the presets to apply it to your clip. Notice that clicking on a preset shows the changes it's applying in the Image and Framing controls on the right side of the GoPro Studio interface.

3. Remove effects from a clip by choosing the none preset or selecting its FX tab in the Storyboard and pressing the Delete key.

Adding Multiple Effects

Multiple effects can be applied to clips, depending on the particular set of effects. For example, vignettes can be applied along with changes to color.

Creating a **New Effects Preset**

You can create and save your own presets that can be applied to multiple clips in current or future projects in GoPro Studio.

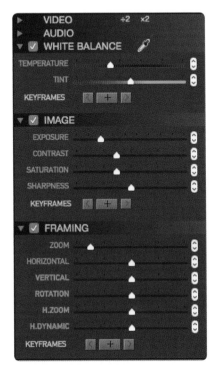

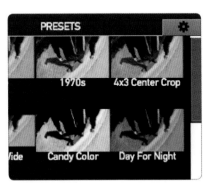

1. Make changes to a clip's White Balance, Image, and Framing controls.

2. Click the Gear icon in the top-right corner of the Presets window.

3. Click the plus symbol in the Manage Presets window.

4. Name your preset and click OK. The new preset appears at the bottom of the Presets lists, where it can be applied to clips in any project. If you want to delete a preset you've created, select it from the Presets list in the Manage Presets window and click the minus symbol.

Importing and Exporting Presets

You can import and export presets you've created from the Manage Presets window for use on another system or when trading presets with other users. Once inside the Manage Presets window, as described previously, simply click either the Export Preset or the Import Preset button.

Applying **Transitions**

Dissolves and fades are useful when you want to smooth the transition between two clips rather than using a straight cut. This is often done to show the passage of time between two shots or to indicate a change in location. You can also use transitions, such as a slow dissolve, between a sequence of several clips or photographs.

Using Dissolves

Dissolves are added between two clips by using the plus icons that appear to join them in the Storyboard. The maximum duration of a dissolve is limited by the amount of media before and after the edit points in adjacent clips.

1. Click the plus icon that connects two clips. The icon should change to indicate a dissolve transition has been added.

2. To change the duration of the dissolve, select the dissolve icon and move the playhead to a new position in the viewer window (the point where you want your dissolve to end). Press the Mark Out button or the O key on your keyboard.

3. To delete a transition, click on its icon (located between the two clips) and press the Delete key on your keyboard.

Using Fades

Fade ins and fade outs are useful transitions at the beginning and end of an entire piece or at the beginning and end of new sections within your video. Typically, fades start from pure black or transition to black. You can adjust the duration of fades to create a faster or slower pace, depending on your project. A slower fade is often used to start or end your video. Ordinary fades may also be used between photos you've placed into a video slideshow.

1. Select a clip in the Storyboard to which you want to add a fade in or fade out.

2. Open the Video options, located on the right side of the interface, by clicking on the arrow next to its name.

3. Adjust the sliders to change the length of the Fade In, the length of the Fade Out, or both.

Transition Tip

While you should use transitions where they're most effective, they're just one way to stitch clips together. In the end, straight cuts are the most common and useful way of joining clips overall. It's about what works best to weave a tapestry out of your footage.

Working with **Music and Sound Effects**

Once you've put together some video in your Storyboard, try adding music or sound effects to make your projects more engaging. Music, in particular, can be important because it sets the tone for a scene or the piece as a whole. You can select a song and add it to your video, fading out at the end.

Adding Audio to the Storyboard

As you add audio to your video, remember that you need to be in the Edit tab for any audio imports to work—it won't import while in the View & Trim tab.

1. Click on the Media button. Choose the audio files you want to import and click Open.

2. Preview audio files and set in and out points by clicking on the file to load it into the viewer window. Use the same playback controls you use for video files. While you play your audio files, the preview window appears black (empty), although you still have control over the sound.

3. Drag and drop audio files from the media list onto one of the two audio tracks at the bottom of the Storyboard. Click and drag to reposition music and sound effects to match or roughly sync with your video.

4. Click and drag the ends of clips to trim the audio.

Adjusting Audio Levels and Applying Fades

Once you've imported and added the audio files to your video, you can adjust the levels and apply fades.

1. Select an audio clip in the Storyboard.

2. Using the Audio controls on the right side of the interface, adjust the Level dB slider up or down, depending on the desired volume of your clip.

3. If you want to add fades to your audio clip, adjust the durations for the Fade In and Fade Out sliders.

Precise Audio Edits

If you need precise control over audio edits, particularly when matching picture and sound (such as when editing to a beat in a music video or highlight reel), it's best to export your video and add your audio in a more professional editing application where you can view waveforms, set markers, and more.

Creating **Titles**

One of the best finishing touches for your GoPro projects is the addition of titles. Titles can be used for any on-screen information, whether funny or informative. They can communicate important information about time and place, as well as credits for the cast and crew. In a rough way, they can also be used for subtitles for the hearing impaired or as translations for other languages.

1. Click the Title button at the top of the Media Bin to add a new title to your project.

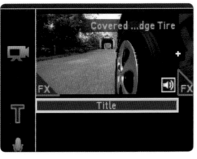

2. Drag and drop the new title clip underneath the desired video clip. Move and trim it as you would any other clip.

3. With the title selected in the Storyboard, type new text into the text box under Fonts on the right side of the interface.

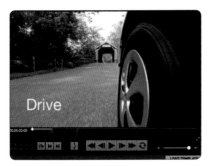

4. Click and drag the text in the viewer window to reposition it.

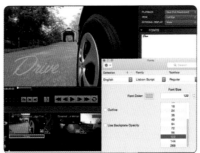

5. Click the current font name (such as "Arial Black") to open a new Fonts window, where you can choose a different font, color, and more for your text.

6. To put a custom colored outline around your text (via the adjacent color swatch), check the Outline box in the Fonts window. Use the slider to adjust the width.

Color Outlines and Backgrounds

Color outlines can be used as an aesthetic choice to add interest, or for practical reasons. For example, a black outline around white text will make it more legible against lighter footage and vice versa. You can also check the Use Backplate Opacity box to access controls for putting solid colors behind the text, covering the entire frame. The Backplate Color swatch gives you access to more colors and opacity controls for this.

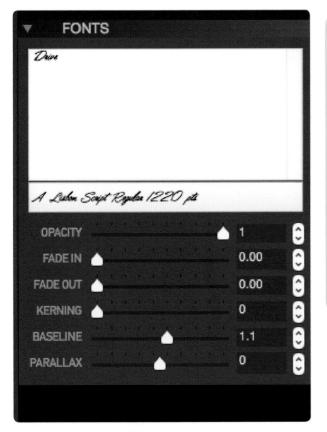

Text Layout

When adding titles, pay special attention to the size of your fonts and their position onscreen. Traditionally, titles are placed in the center, in the lower left third of the screen, or in the lower right third of the screen. While you can experiment with other placements, make sure to give your text enough breathing room around the edges of the screen. An adequate amount of spacing looks nicer and can be important, as some displays cut off the edges of the frame.

7. With the Title selected in the Storyboard, adjust the Opacity, add a Fade In or Fade Out, and make other changes to your text in the Fonts window on the right.

Exporting Your **Finished Video**

Your video's now finished in GoPro Studio! Is this a video for your blog or YouTube channel? Do you want to export a copy for editing in more advanced software; such as Adobe Premiere or Final Cut Pro? All of these uses and more can be accommodated in the export process.

1. Choose Share > Export .mov or click the Export tab at the top of the interface.

2. Name your video in the Export As field and choose a location on your computer to save it in the Where drop-down menu.

3. Select an output format from the Preset drop-down in the main Export window. Notice there are presets for YouTube and Vimeo. You can also choose the Custom option, which provides advanced settings for Quality, Image Size, Frame Rate, and Encode As (including the professional GoPro CineForm codec).

4. Look at the Duration and File Size information to make sure it's okay for uploading and storage. Click Export to start the encoding process.

Exporting **Still Images**

Saving a frame in your video as a still image is great for creating thumbnails to best identify your video clips when uploading them to an online gallery or portfolio. You may even choose to shoot in Video mode with the intention of extracting frames for still photos, as opposed to using the Photo mode on your camera.

1. Move the playhead to the desired frame in your clip.

Resolution Settings

Select the highest resolution you can for the best results—in this case, 4K is great for extracting high-quality still images. Just be careful to reduce motion blur in your shots by shooting in adequate light with minimal movement and at higher frame rates when possible.

2. Choose Share > Export Still (Mac) or File > Export > Still Image (PC).

3. Name your image in the Export As field and choose a save location in the Where drop-down menu.

4. In the Size to Export drop-down menu, choose Small, Medium, Large, or Native. Click Export when you're finished.

Publishing Your Video Online

When you're done creating your GoPro masterpiece, why not share it online? As you've seen with the Export options, there are presets already set up to help you deliver your video for sites like YouTube and Vimeo, and those presets should work for Facebook as well. The following are some things to keep in mind when uploading online.

Preset: Vimeo Duration: 00:00:13 File Size: ~26.8MB

Cancel Export

- **Always use the best settings possible (higher bit rates).** Video sharing sites will often recompress your footage again when it's uploaded, further reducing the quality of your pristine originals.

- **Balance quality with file size when making longer videos, depending on the platform you're using to publish.** For example, certain accounts on Vimeo will limit the amount of data you can upload at one time.

- **Music may be flagged.** When uploading any footage containing music, be aware that sites like YouTube may flag it for using "music owned by a third party." However, any of the music that GoPro Studio includes with their GoPro Edit Templates is fine to include.

- **Hashtag your videos.** Remember to use hashtags such as #gopro, #goprohero4, and more, especially on sites like Twitter, Instagram, and anywhere else it's an option. Let people know about the camera that made it happen!

Submitting Your Video to the
GoPro Channel

Don't forget to submit your best videos for inclusion on the popular GoPro channel. Submissions are accepted through the GoPro website (gopro.com/channel), which requires you to create a login. Once you've done that, GoPro staff will pick their favorite videos and promote them. Of course, the more interesting, unusual, and dynamic your videos, the greater your chance of being selected. GoPro accepts content that's submitted as photos, raw clips, or video edits.

Be Creative!

Creativity is key. If you haven't already, check out the entries that have been accepted so far. There's a wide variety of videos, but looking more closely at the channel should give you an idea of what they're most interested in seeing. Sports, action, and adventure are obvious favorites. But videos of music, art, travel, how-to, kids, pets, and nature are considered well-liked content. Pretty much everything is fair game, amateur or professional, as long as it's well made and engaging.

Permissions and Licensing

Be sure to get permissions from people that you film. Also, use caution with unlicensed music. See the GoPro website for restrictions, as well as terms and conditions for their GoPro Awards (which includes cash prizes).

Part 2:
Projects

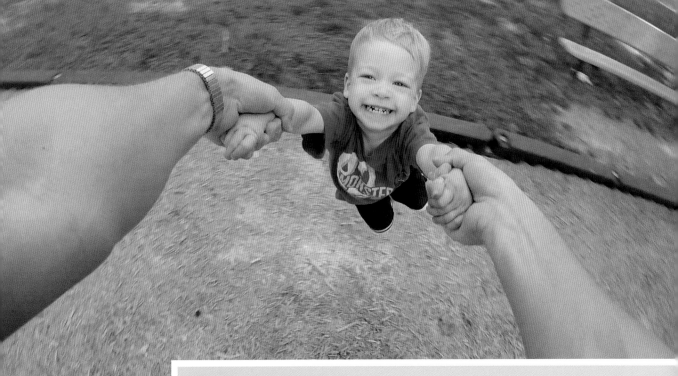

Home

Record a **Day in the Life**

 EASY

EQUIPMENT

The Frame

Lanyard, #10-32 Nut, and Thumb Screw

Neck Strap with GoPro Buckle (Optional)

QuickClip

Camera Lens Cover

A GoPro is a useful companion for chronicling your daily routines, whether you're live blogging your life or creating a time capsule for posterity.

Planning the Shot

While activities that involve action are best, anything is fair game, from ordinary rituals to special celebrations. Keeping the camera available but reasonably inconspicuous is important, so consider using the QuickClip or hanging the camera around your neck. A camera lens cover is also recommended to avoid scratching your lens while out and about. If you plan to record while the GoPro is attached to a lanyard, you can flip the image in the camera's Setup mode. The best option, if using the Hero4 Black or Silver, is to set the image orientation to Auto. And be sure to enable QuikCapture so you can record the day's events with a single press of the Shutter/Select button.

1. Make a GoPro neck strap by attaching a lanyard to The Frame using a #10-32 nut and a Thumb Screw. Alternately, purchase a neck strap with the standard GoPro buckle.

2. Wear the GoPro around your neck and lift it to take photos or video throughout the day.

3. Take interesting shots as you go about your day, such as driving through the car wash.

4. See the sights on your way to work or while traveling.

5. In The Frame, you can then attach the GoPro to a hat or other item with a QuickClip for a different perspective.

6. The QuickClip can capture your point of view of celebrations with family and friends.

Hit the Settings/Tag button to place a HiLight Tag.

HiLight Tagging

Certain moments throughout your day will be more interesting than others. With the HiLight Tag feature, you can find those moments more easily later on. Simply press the Settings/Tag button while the camera is recording to place a HiLight Tag (or use the app). You can then look for those labeled clips in the GoPro Studio software when you edit.

See the World from **Your Dog's Perspective**

EASY

EQUIPMENT

Standard Housing
Fetch

Interested in what your furry friend sees every day? Attach the GoPro to your dog and let it film. You never know—you might get some interesting home movies out of it.

Planning the Shot

Attaching a GoPro to your pet is easiest with the Fetch dog harness. While the mount covers a wide range of body types—from 15 to 120 pounds (7 to 54kg)—it won't work as well with very small canines. For short dogs, you can remove the chest mount, if necessary. The included camera tether is optional but recommended for active dogs. Once the Fetch is properly fitted to the dog, you should be able to get it on and off more easily for future outings. When it comes to images, high frame rates—such as 48 or 60 fps—should give better results, particularly when your dog is running or jumping. And depending on your dog's physical characteristics, you may want to tilt your camera more or adjust the View mode to accommodate a vertical image (for example, with SuperView, 1440p, or 2.7K 4.3 modes).

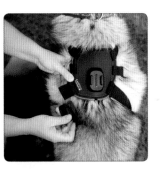

1. Place your GoPro in the Standard Housing. Loosen the straps and slip the Fetch over your dog's head.

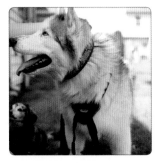

2. Pass the straps under your dog's legs and around its chest, connecting the straps with hooks.

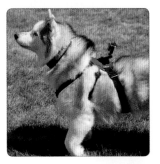

3. Adjust the straps for a snug fit. Place the camera on the back mount using the vertical buckle included with the harness.

4. Capture an over-the-head view of your dog's world.

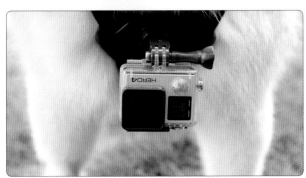

5. Remove the camera from your dog's back and place it on the chest mount, facing it forward or tilting it upward.

6. Shoot action closer to your dog's point of view, or try out more extreme angles from below.

Looping Video Clips and Animated Gifs

If you have a particularly funny, cute, or impressive moment of your pet's antics to share, consider making a 6-second looping Vine video or a 15-second looping Instagram video out of it. Simply use the video Trim and Share feature on GoPro cameras or the GoPro app to create the short clips. You can also bring your footage into another app (such as Photoshop) to create an animated gif, which is popular on sites like Tumblr.

Play with Your Food in the Kitchen

⚡ **EASY**

EQUIPMENT | Standard Housing or The Frame
The Strap

You don't have to be Alton Brown to have fun in the kitchen. Even preparation and cleanup can be a blast if seen from the perspective of a GoPro.

Planning the Shot

Cooking shows are incredibly popular, and there's no reason you can't make your own. For a serious production, you'll want to storyboard or carefully plan each step of the process. However, even a more informal documentation of the day's menu could make a nice surprise for dinner guests after some cleanup and a quick edit. If you're working in a kitchen with low light levels, use lower frame rates—such as 24 or 30 fps—so slower shutter speeds are available. If possible, place additional lights or lamps nearby to spotlight the process. You can use the Standard Housing or The Frame to protect your camera from splashes and other mishaps.

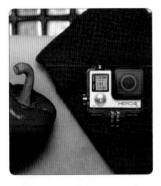

1. Simply place the camera (in the Standard Housing or The Frame) near the action, but far enough away to achieve focus.

2. Place the GoPro in the refrigerator, close the doors, and record yourself opening them again to take out food.

3. Set the GoPro in bottom of the sink, turn on the water, and wash vegetables.

4. Chop fruits and vegetables or shred cheese with the camera on the counter.

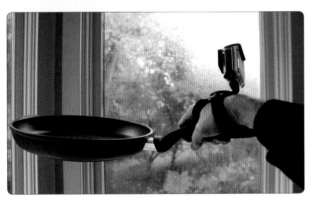

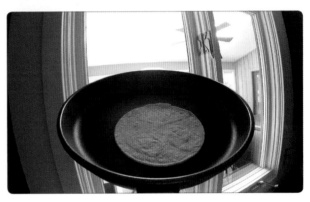

5. You can then attach the GoPro to your hand or wrist with The Strap.

6. Flip a pancake or fry a tortilla while using The Strap to follow your movements.

Other Options

Beyond sitting it on a table or using The Strap, you can place your GoPro and a light source in the dishwasher—if you dare. (However, I recommend not drying or using soap if you turn it on.) Another option is to attach the camera to a Chesty; with this setup, you can capture engaging shots from the diner's point of view.

Have Fun with a **Motorized Toy Car**

 EASY

Got a remote control car, boat, or helicopter in the closet? If it's big enough to attach a GoPro, chances are you can put it in the center of the action.

Planning the Shot

The size of your motorized vehicle, its center of gravity, and its basic design will have an impact on how you attach your GoPro. Also, consider how permanent you want the mounting points to be. Is the camera going to stay in one place, or are you planning to swap the camera's position? You have many do-it-yourself mounting options, so feel free to experiment. Any mounts included with your GoPro are more long-term options, while the Instrument Mount works for low-impact driving with easy removal. Whatever the case, use caution when attaching the mount so you don't damage the vehicle's paint or finish. Ideally, if the vehicle's body is removable, you could rig a magnetic mount by taping strong rare-earth magnets under the roof of the vehicle and beneath the mounting plate.

1. Select an appropriate-size vehicle to which you can attach the GoPro, such as a 1:14 (green) or 1:24 (white) scale car.

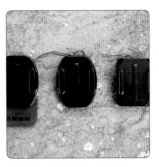

2. Choose a Flat Adhesive Mount, Curved Adhesive Mount, or Instrument Mount, depending on the surface of vehicle.

3a. If you're using the free mount (Flat or Curved) from the packaging, attach it to the vehicle's roof with rubber bands, gaffer tape, or magnets.

3b. Alternately, connect the GoPro with the easily removable yet solid Instrument Mount.

VARIATION

You can also reposition the camera for more interesting angles, such as looking back at the car. Just make sure the weight is evenly distributed so the camera or vehicle isn't damaged.

4. Adjust the camera angle to include the windshield of the vehicle in the frame.

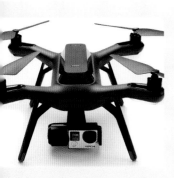

Using Drones or UAVs

With a GoPro, you're not limited to terrestrial views of the world. In recent years, unmanned aerial vehicles (UAV), or drones, have taken to the skies in a big way. Popular drone offerings from companies like DJI and 3D Robotics (3DR) provide mounting options for a GoPro, with three-axis gimbals for good stability. While local, national, and international laws can make flying a drone something of a headache at the moment, armed with a few legal guidelines, a little common sense, and the right vehicle, hobbyists and professionals alike can achieve big-budget image results with a small investment.

Go for a Spin with a Hula Hoop

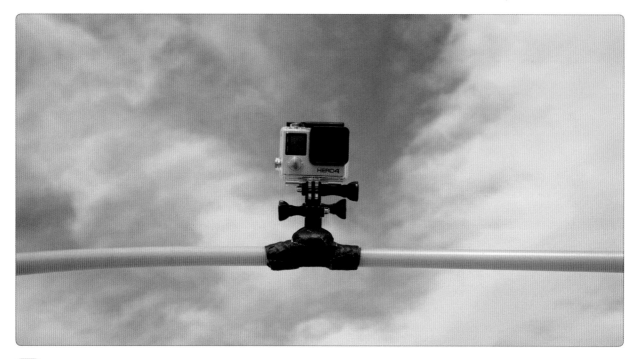

EASY

EQUIPMENT

Helmet Front Mount

Gaffer or Electrical Tape

Hula hoops are synonymous with fun. Attaching a GoPro to these flying donuts creates a strangely hypnotic effect that's sure to captivate viewers of all ages.

Planning the Shot

Find the strongest and thickest hula hoop possible, because the camera's weight causes significant flex of the ring. You should then make sure the camera is securely attached to the hoop before you send it spinning. For this project, you stick primarily with tape, though if you're feeling more industrious, you can drill holes and bind the mount with wire or zip ties before applying adhesive. As for location, it's best to film on sand or soft grass, which should cushion the hoop's inevitable fall. While balance is an issue when the hoop starts spinning, gravitational forces and a talented spinner should be able to keep it aloft. In addition to your waist, you can try spinning the hoop around your arms (with the camera inside the circle) for a different view.

1. Select a hula hoop of appropriate size and strength, such as a 40-inch (101.5cm) hoop with a ¾-inch (2cm) tube diameter.

2. Use the Helmet Front Mount to attach the camera to the hoop.

3. Place the adhesive mount portion onto the ring of the hoop and allow it to adhere (where possible) to the surface.

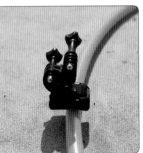

4. Attach the buckle portion to the mount, along with the optional extension arms, which shift the camera's center of balance over the hoop.

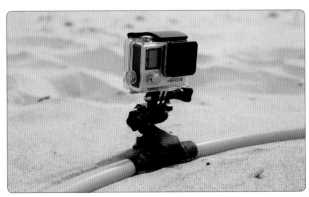

5. Securely wrap the mount with gaffer or electrical tape, and then mount the camera.

6. Adjust the camera angle, strongly tightening the screws, and then start spinning the hoop.

Attaching to Jump Ropes

For a greater challenge, try attaching the GoPro to a jump rope. Keeping the camera properly balanced and consistently aimed at the center is tricky to achieve, though centripetal force plays a part. Check out YouTube for examples of GoPros attached to jump ropes to see what people have done. The best ones don't use a typical jump rope; instead, they employ a more rigid setup to simulate the effect. The result is otherworldly when done right.

Submerge Your Camera in an Aquarium

 EASY

EQUIPMENT

Standard or Dive Housing

Free Mount from Camera Packaging or Flat Adhesive Mount

Macro Lens Adapter

Mic Stand Adapter

Mic Stand Mount

Mysteries of the deep it's not, but home aquariums have their own secrets to reveal, including an unusual inside-out perspective.

Planning the Shot

No matter whether you have a big or little tank, you'll need to waterproof your camera, which means snapping your GoPro into the Standard Housing or Dive Housing. You can achieve sharp images below the water, even in an aquarium, with both of these housings and their flat lens. Still, close subjects (less than 12 inches; 30.5cm) will be a little fuzzy or out of focus without a macro lens adapter. The free mount that holds a GoPro in its packaging is useful as a plate to mount the camera and then set it on the bottom of a tank or anchor it under the rocks. For shots looking down on the tank or through the glass on a side, using a tripod is difficult. For this reason, an inexpensive Mic Stand Mount, along with a Mic Stand Adapter, makes getting against or above the tank a breeze.

1. Choose between the Standard Housing (left) and Dive Housing (right) for your underwater adventures.

2. Attach a macro lens adapter, attach the camera to the free mount or a Flat Adhesive Mount, and set the camera on the bottom of the aquarium.

3. Adjust the angle of the camera for unusually intimate views of fish and other aquatic life in your midst.

4. Next, using the Mic Stand Adapter and Mic Stand Mount, move the camera so it sits directly above the tank.

5. Notice how a top-down perspective yields clear views, at least when unobstructed by lights and filtration systems.

Shooting in a Pool

If swimming in an enclosed space is more your thing, dive into a local pool with your camera instead. A seaworthy pole or handgrip (like The Handler, shown here) can be a lifesaver in deep water, while an extension is great for close-up filming. You can also set the camera on the bottom of the pool; use the plate that came with your camera and place a sandbag or small barbell on top to pin it down. Activate the QuikCapture mode beforehand so you don't have to fiddle with settings underwater.

Be a Kid at the Playground

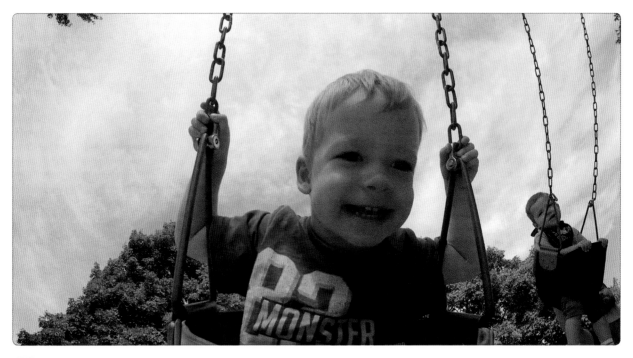

EASY

EQUIPMENT

Standard Housing

Jaws: Flex Clamp

Chesty

Junior Chesty or Head Strap

Playgrounds offer a variety of ways to have fun with a GoPro. The next time you're out with the kids, turn playtime into an adventure with everyone's favorite action camera.

Planning the Shot

The next time you head out to the playground, bring your camera secured in the Standard Housing and a versatile mount or two, such as a Jaws: Flex Clamp, a Chesty, and a Junior Chesty. The Jaws: Flex Clamp is especially handy in this environment, thanks to the numerous bars, chains, and other mounting points you'll find. Meanwhile, the Junior Chesty—or an impromptu shoulder and chest strap via the Head Strap—can follow the kids' every movement. Even without a mount, you can place a GoPro on the ground or hold onto it. The kids can then go on the swings, zip down a slide, climb the monkey bars, and spin around. Whatever they decide to do, these videos will be amazing mementos for when they're older (and using their own GoPro for adventures like skydiving or surfing).

1. Mount the Jaws: Flex Clamp on the front or back of a swing.

2. Capture candid portraits of the kids from the front, as well as unique perspectives from above the ground.

3. A shot from the back is especially nice when you plan to edit together action from front to back.

4. For shots from your point of view, attach the camera to the Chesty.

5. Swing the kids around to capture exciting action shots with the Chesty.

6. Place a Junior Chesty on the kids, or improvise a similar harness using the Head Strap, to get shots from their point of view.

7. Enjoy their perspective of going down a slide.

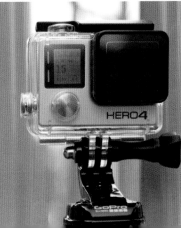

8. Record life's small moments, like tying a shoe and interacting with family and friends.

Stationary Shots

Instead of using a tripod, attach the Jaws: Flex Clamp to mounting points throughout the playground.

Attack the Yard with Power Tools

 EASY

EQUIPMENT

Standard Housing

Handlebar/Seatpost/Pole Mount or Roll Bar Mount

3-Way Pivot Arm (Optional)

Jaws: Flex Clamp

Rubber Locking Plug

Chores don't have to be boring. Attach your GoPro to a few power tools and turn even the most laborious tasks into thrilling outdoor action shots.

Planning the Shot

When working with power tools, safety comes first. While you can look for opportunities to view mechanical operations in a new way, such as the rotation of a chainsaw, don't do anything that will threaten the well-being of yourself or your camera. The Handlebar/Seatpost/Pole Mount or Roll Bar Mount provides a secure connection in many cases and gives a more hands-on perspective, while the Jaws: Flex Clamp allows you to capture unique shots of the tool itself. Because vibrations are a serious issue with power tools, you should shoot at a higher frame rate (such as 60 fps). You can also use the Rubber Locking Plug to better stabilize the camera while it's in the Standard Housing. While some tools may not yield the shots you want, experimenting to discover what works is part of the fun.

1. Attach the Handlebar/Seatpost/Pole Mount or Roll Bar Mount to a lawnmower, turning the camera 90° with a 3-Way Pivot Arm, if necessary.

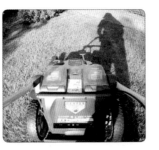

2. Adjust the downward angle of the camera for the best view and record the action.

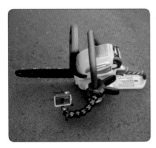

3. You can also fasten the Handlebar/Seatpost/Pole Mount or Roll Bar Mount to edge and hedge trimmers.

4. When filming with trimmers, keep the lens clear of flying debris, such as grass.

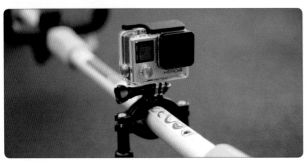

5. Try the Jaws: Flex Clamp with a chainsaw, along with a Rubber Locking Plug to help with vibrations.

6. Carefully position the Jaws: Flex Clamp to view the side of your chainsaw blade as it cuts.

Warning

When filming with trimmers, chainsaws, and leaf blowers, watch out for flying debris hitting the camera (or your eyes). Keeping your GoPro in its case will protect the lens, but even cases scratch, and a stray rock or twig may affect video quality. If your case's lens cover gets scratched, you can replace it with the official Lens Replacement Kit from GoPro, which is cheaper than buying a new case.

Conduct Home Inspections and Repairs

 EASY

EQUIPMENT

Standard Housing

Handlebar/Seatpost/Pole Mount

Painter's Pole or Long Stick

Flashlight

Gaffer or Electrical Tape

While a GoPro has many entertaining uses, its utilitarian possibilities—such as recording a home inspection—might surprise you. It's like the Swiss Army knife of cameras.

Planning the Shot

Instead of using mirrors or other specialized devices for inspecting your home's roof or crawlspaces, try a pole-mounted GoPro instead. Use a Handlebar/Seatpost/Pole Mount or Roll Bar Mount (depending on thickness of pole) to attach your camera, making sure it's securely mounted, and adjust its angle for a suitable view. For example, when surveying a roof, you may need to tilt the camera so it's nearly parallel with the pole. It's a good way to keep an eye on problem areas and to check up on repairs. You can then use the GoPro app to guide the camera while watching from above or below, recording the view for later scrutiny. Even a GoPro placed behind an appliance or slipped under a couch could help you locate missing items or things that need fixing.

1. Attach the Handlebar/Seatpost/Pole Mount to a painter's pole or other long stick. Place the GoPro in the Standard Housing and connect.

2. Adjust the downward angle of the camera and extend the pole to the appropriate length.

3. Lift the pole to begin your inspection, monitoring the camera's view with the GoPro app.

4. Capture video for later analysis, or use Live Preview from the app to check areas without recording them.

5. For viewing darker and more cramped areas, attach a flashlight to the pole holding your GoPro with gaffer or electrical tape.

6. Use this setup to look underneath your car and in other hard-to-see locations.

Keeping a Record for Insurance Claims

Insurance companies encourage you to keep records of all the items in your home. In addition to written records and receipts, you can use a GoPro to document your belongings. In the event of a fire, burglary, or natural disaster, you (or the insurer) can review the video for visual confirmation of items that were lost, stolen, or damaged. Make sure to store a copy of the video (along with copies of your written records) in a location other than your home, or upload them to a secure online storage site.

Improvise a Security Camera or
Baby Monitor

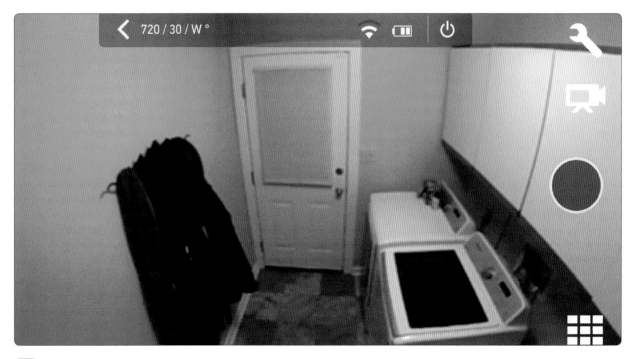

ADVANCED

EQUIPMENT

The Frame

Flat Adhesive Mount, 3-Way
Pivot Arm, Jaws: Flex Clamp, or
Other Mount

USB Cable (Optional)

Micro HDMI Cable (Optional)

Whether for short-term security or child safety monitoring,
you can watch a room while in another area of your house
using GoPro's remote viewing and control features.

Planning the Shot

Before you begin, a note of warning: a GoPro can't take the place of a true security
camera. It requires separate power, has limited record times, and can't stream
directly to a network (at least, not without a lot of networking voodoo). However, by
connecting a GoPro to an iOS or Android device and using settings that increase
record time, this camera can help you with impromptu security and home-monitoring
situations. For times when you want the camera to go undetected, turn off LED Blink
and Beeps before mounting it. To increase your storage options, you can choose to
capture to an external recorder via the HDMI connection. If you want to add power,
connect a cable to a standard USB port.

1. Place the GoPro in The Frame. Secure your camera with a Flat Adhesive Mount, 3-Way Pivot Arm, Jaws: Flex Clamp, or other mount.

SETTINGS/TAG BUTTON

2. Activate your camera's WiFi feature by pressing and holding the Settings/Tag button until the WiFi indicator illuminates.

3. Connect your camera by selecting it in your device's WiFi settings.

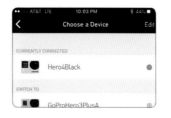

4. Open the GoPro app and choose the camera you want to connect.

5. Choose a lower resolution and frame rate to conserve storage space, such as 720p 30.

6. If you want to extend operating time, attach a long USB cable and plug it into a power source.

7. For more storage, connect your GoPro to an external HDMI signal recorder or wireless transmitter using the Micro HDMI Cable.

8. Use your iOS or Android device to view live video when in reach of your camera's WiFi signal or to activate recording.

Adding a Motion Detector

Most security systems have the option to trigger a recording based on motion within the frame, such as someone approaching your door. Companies like Cam-Do sell motion detectors for GoPros; however, just know you're required to install custom firmware on your camera.

Nature

Take a Hike in the Wilderness

 EASY

EQUIPMENT

Standard Housing

Chesty

Special Chest and Back Mount
(Optional)

Smart Remote (Optional)

The Strap

Hiking allows you to exercise with the stunning backdrop of the natural world. On your next trek, bring along a GoPro instead of a bulkier camera to document your journey.

Planning the Shot

Before heading out, place your camera in the Standard Housing and pack a couple harnesses in your bag. The Chesty is always a good choice, and one you shouldn't leave behind. Another option is using a backpack with built-in harnesses or specialty mounts for shoulder straps and triggering when to shoot with the Smart Remote. And, though it might get in the way at times or prove uncomfortable on hot days, The Strap is a versatile option for capturing photos from different perspectives. If you decide to hold the GoPro in your hand, you may wonder how you can keep the camera steady. If you're not using a harness, simply place your GoPro against your chin or face for better stability.

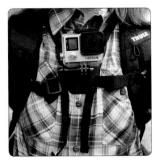

1a. Use the Chesty to obtain great walking shots. Shown here is an integrated mount on a backpack.

1b. Alternately, attach the camera to your chest or back with special mounts, such as this backpack with its included attachment points (one of which is built in).

2. Trigger your shot manually or with the Smart Remote.

3. Use chest-mounted shots for general walking or interactions and investigation, such as identifying flora and fauna.

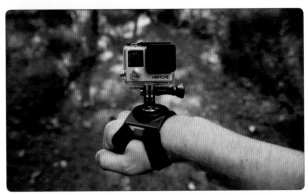

4. For more versatile shooting options, place the camera in The Strap and attach it to your hand.

5. Use The Strap to capture photos of yourself on the trail or to narrate various encounters.

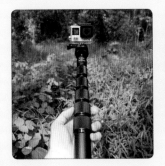

Other Equipment

While taking in your surroundings, an extension pole (left) can help you check out-of-reach places or get the perfect photo. For power while on long hikes, carry a USB battery and solar charger (right) with you.

Watch Birds on Feeders

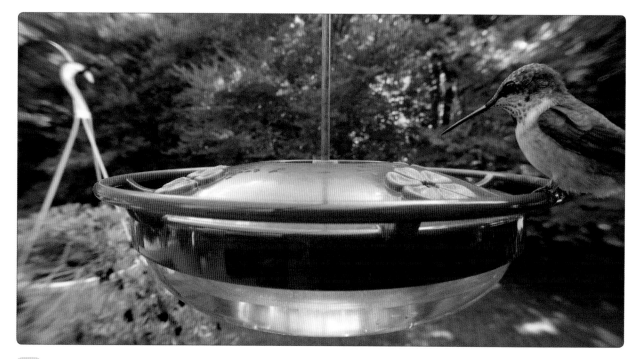

EQUIPMENT

Macro Lens (Optional)

Tripod or Light Stand

Tripod Mount Adapter

Jaws: Flex Clamp (Optional)

Equal parts 7-Eleven and neighborhood water cooler for birds, feeders are where you can catch up on some backyard drama with your GoPro.

Planning the Shot

Time of day is critical to capturing footage of birds. Early morning and late afternoon are your best bets, though birds will visit throughout the day. In particular, you may find your feeders are busiest when other food is scarce in harsher weather, such as in the winter. Patience is key if you want a good shot, so plan to spend some time waiting nearby with your GoPro app open. Because birds make twitchy subjects, if you're shooting photos, set your GoPro to Burst or Continuous to capture a series of photos, and then select the best ones later on. For video capture, higher frame rates—such as 48 or 60 fps—may yield the best motion results in adequate light.

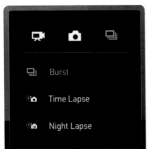

1. Set the GoPro to shoot Video or Photo (if Photo, select Burst or Continuous). Turn off blinking LEDs and Beeps so you don't disturb the birds.

2. Attach a macro lens if you're shooting closer than 1 foot (30.5cm) from your subject.

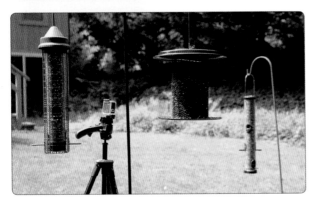

3a. Secure the GoPro to a tripod or light stand using the Tripod Mount Adapter.

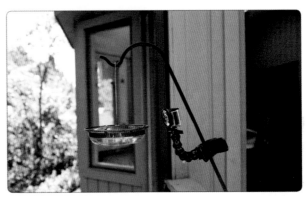

3b. Alternately, clip the GoPro to a railing using the Jaws: Flex Clamp.

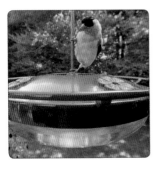

4. Watch the feeder from a distance using the GoPro app on your phone or tablet. Use the app to start recording.

5. Reposition the camera if necessary to adjust the framing and to maintain focus.

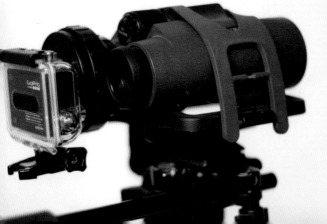

Mounting Cameras on Binoculars or a Scope

Serious birders know that nothing beats a great pair of binoculars or a high-powered scope. While capturing what your eyes see through these instruments using a camera is tricky (also called *digiscoping*), it's made easier with adapters specifically designed for your camera by companies like Phone Skope.

Explore Creeks and Rivers

EQUIPMENT

Extension Arm

Painter's Pole Adapter (Optional)

Painter's Pole (Optional)

Standard Housing or Dive Housing

There's a lot to discover in your local waterways. Whether you're an expert or a budding naturalist, a waterproof camera can help you explore these bodies of water.

Planning the Shot

Creeks and rivers are full of interesting fish, plants, rocks and minerals, and even the occasional mammal. While waders and waterproof boots are nice to have for exploration, they can stir up dirt on the bottom of a riverbed or creek bed, creating a cloudy mess that even the best cameras won't cut through. Use an extension arm or a long pole to access out-of-reach areas or to delve under the surface without wading into the deep end. You can use either the Standard Housing or the Dive Housing for these expeditions because both housings have flat glass for sharp images, even in shallow water. Keep an eye on things above water as well—you never know what you might find along the riverbanks.

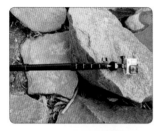

1a. Carry an extension arm with you whenever you go exploring—even a small one can come in handy.

1b. Use the extension arm for exploration near the shore, as well as for wide shots of scenery and yourself.

1c. Alternately, attach a painter's pole adapter to a long painter's pole, if you have these, to achieve a much longer reach.

2. With your GoPro in the Standard Housing or the Dive Housing, use the extension arm or pole to dip the camera into the water.

3. Bring land and water together by shooting on the water line (done with the Dive Housing here).

4. Place the camera underwater looking up at trees, sky, and fish passing overhead (seen here in the Standard Housing in a creek).

5. Don't neglect the riverbanks, where kingfishers ply their trade, otters might be sunning, and odd treasures can be found.

POV Shots

To get a great shot of the creek or river from your point of view, put on a Chesty. For instance, this shot was taken from inside a raincoat via a Chesty while using a painter's pole in the water.

Observe Flowers Up Close

⚡ **MODERATE**

EQUIPMENT
Standard Housing
Macro Lens

With a GoPro, you can get an intimate look at the colors and textures that make up the different wondrous blooms in a garden—as well as the creatures that visit it.

Planning the Shot

With a simple modification, and by keeping some key principles in mind, a GoPro can capture life at a small scale. Most importantly, consider the minimum focus distance of the camera's lens. Once you get closer than a foot to your subject, near focus becomes difficult or impossible. For this reason, macro lenses are essential. Because macro subjects require a lot of light for proper exposure and a suitable depth of field, you should think about the direction and amount of light available. You also want to avoid casting shadows on your subject. Ring lights solve some of these problems by providing even illumination for subjects directly in front of the lens.

1. Place the camera in the Standard Housing. Attach a macro lens with the desired power to your GoPro, such as a +10 diopter or a filter with 3.8x magnification.

2. Turn LED Blink to Off in the Setup menu to avoid casting red light on close subjects.

3. Determine the distance to the subject. Have the camera within focus range—about 3 to 12 inches (7.5 to 30.5cm) away at 3.8x magnification.

4. While the edges of the image will blur, the center should be in focus at the right distance.

5. Take pictures of anything else that interests you, such as insects, eliminating distractions and focusing on details.

NEED MORE LIGHT?
If the subject requires more illumination, consider using a ring light or other source; however, it may inhibit the use of adapters.

Working with Macro Lenses

Several companies sell macro lens attachments for GoPro cameras based on particular housings. Before you purchase any, decide which housing you'll use the most, whether you'll need an adapter for it, and how much you want to invest in a system. You can purchase lenses in a range of powers, or diopters, such as +1, +2, +4, and +10—the larger the number, the more powerful the magnification. Just keep in mind that the maximum and minimum focus distance of your lens will be limited based on the diopter you've chosen, and more powerful lenses tend to degrade the image quality.

Sports

Improve Your Swing on the Golf Course

EASY

EQUIPMENT

The Frame

QuickClip

Handlebar/Seatpost/Pole Mount
or Roll Bar Mount

Golf has always had plenty of drama and athleticism. But capturing the experience wasn't as easy until the GoPro came along.

Planning the Shot

Shooting a day on the links shouldn't be stressful, and it certainly shouldn't hold up other players on the course. Fortunately, the best shots for golf require minimal gear and quick changes. A useful mount for this sport is the QuickClip, which attaches to your cap. Just make sure the cap is fitted (very) tightly to your head; otherwise, it will fall off easily with a GoPro attached. The Handlebar/Seatpost/Pole Mount or Roll Bar Mount also yields interesting shots that closely follow the motion of a club. Depending on your technique, securing it to the handle might interfere a bit with play, contingent on the club, though additional padding might hold it more securely. Of course, care should also be taken on forceful swings so the GoPro and any attachments aren't damaged.

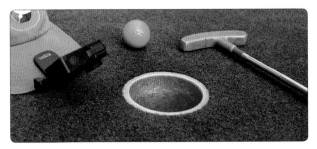

1. Attach the GoPro in The Frame mount to a QuickClip. Clip it onto the brim of a cap.

2. Use a QuickClip to shoot from the golfer's point of view, capturing the arms, legs, and club in action.

3. To shoot unique motion and to get a closer view of the ball, attach the Handlebar/ Seatpost/Pole Mount or Roll Bar Mount to the club.

4. The Handlebar/ Seatpost/Pole Mount or Roll Bar Mount follows the motion of your club and more precisely shows lining up a shot and hitting the ball.

OTHER POV AND WIDE SHOTS

You can simulate the ball's point of view by placing your GoPro in a golf ball hole. But keep in mind that lens placement on all GoPro cameras except the Session is to one side, which prevents perfect centering. If you're carrying your clubs in a bag or cart nearby, the Jaws: Flex Clamp is an option for wider shots. However, it tends to move or vibrate too much when attached to a club.

Analyzing Your Technique

If you're a regular golfer who wants to work on perfecting your form and technique, it's useful to record yourself playing golf and practicing your swings. Later on, you can analyze the footage yourself or show it to a more experienced golfer for constructive criticism. Use a high frame rate, such as 60 fps or 120 fps, to slow down your footage for finer scrutiny.

Shoot Better on the Basketball Court

EASY

EQUIPMENT

Standard Housing

Chesty

Head Strap or Jaws: Flex Clamp

Basketball involves several athletes in constant motion, as well as fixed goals and clear vantage points. These are great subjects for action cameras like the GoPro.

Planning the Shot

While shooting basketball with a GoPro can be exciting, it can also be tricky, since there's a wide range of motion to consider. The high-impact motions, such as running and jumping, can be jarring to watch from a first-person point of view. Therefore, it's a good idea to use those shots judiciously in your edits, cutting between wide shots, fixed camera positions (above the hoop, for example), and other static moments while mixing in the more interesting elements from the Chesty or Head Strap. So the next time you play basketball with friends, ask them to bring their GoPros, too, and see what positions work best. And although it adds weight, use the Standard Housing to prevent damage to your camera.

1. Attach your camera to the Chesty for views of the player, including hands and arms.

2. When using the Chesty, angle the camera upward a bit (tilting it back) for the best views.

3. You can then wear the Head Strap or attach the Jaws: Flex Clamp to certain areas of the court for flexible angles.

4. You can look downward at the ball and a player (as shown here), or forward at other players and the court.

5. Changing the angle creates a different sense of motion, either leaning into or away from the player.

Changing the Look of Professional Sports

The GoPro aesthetic has influenced many genres, none more so than sports. While extreme sports genres like surfing, snowboarding, racing, and more have been using GoPro cameras for some time, it wasn't until recently that more traditional sports venues (such as ice hockey with the NHL) have begun to use them. This is due in large part to the new HEROCast, or the professional broadcast solution that adds wireless HD, allowing producers to incorporate player and arena cameras directly into their live broadcasts.

Catch Some Waves with a Bodyboard

 EASY

EQUIPMENT

Bodyboard Mount

Phillips-Head Screwdriver

Coin

Standard Housing

Floaty Backdoor

Camera Tether

Locking Plug

Bodyboarding, surfing, and other water sports are practically synonymous with GoPro, the action camera that stays dry in the wildest waves.

Planning the Shot

Attach your GoPro to a bodyboard using the Bodyboard Mount and the various pieces that come in its kit, along with a Floaty Backdoor for added security. The process of attaching this mount is permanent, creating a hole in your board if removed, so think carefully about how you want to set it up. Check the thickness of your board and match it with the proper screw, while leaving enough space along the edges and near the leash per the included instructions. Also, if you usually move left, place the mount on the right, and vice versa. Once the mount is attached, position the camera facing backward toward the rider or forward toward the waves. And don't forget to attach a leash on your board, so you don't lose it along with your camera.

1. Select an appropriate bodyboard and determine where you want to place the camera.

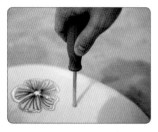

2. Use a Phillips-head screwdriver to make a hole in the board passing to the other side, twisting the screwdriver to widen the hole.

3. Use the arrow included with the Bodyboard Mount kit to choose your camera angle before pressing the mount into the board. (It can't be altered later.)

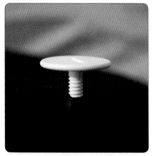

4. Select a short or long base screw from the kit, depending on the board thickness. Screw it into the mount from the back using a coin.

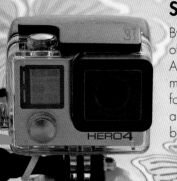

5. Replace the backdoor on the Standard Housing with the Floaty Backdoor.

6. Place your GoPro into the mount (facing forward or backward). Attach the Camera Tether and Locking Plug for added security.

7. Take your board with your attached camera into the water, keeping in mind that strong waves can affect the camera's angle and security.

Surfing with a GoPro

By now, you've probably seen the surfing videos that made the GoPro famous. Most of these were shot using one of the Surfboard Mounts, which are more like Flat Adhesive Mounts with stronger adhesive than the Bodyboard Mount. If you decide to mount your GoPro for surfing, it's particularly important to allow the mounts to adhere for 24 hours before using. It's also important to use a Camera Tether, Locking Plug, and Floaty Backdoor, because strong waves sometimes rip the mounts from the board—and you don't want to lose your camera.

Take Aim with **Archery**

⚡ **MODERATE**

Attaching a GoPro to a bow turns target practice into an action movie—with stationary targets. Skeet shooting, fishing, and other sports are also amenable to this.

Planning the Shot

To begin, it's important to handle the bow safely and responsibly both when you attach your camera to it and while it's in operation. When selecting a position for your camera, make sure it won't interfere with the path of the string, the arrow, or the arrow's fletching and feathers. It's also important that the normal positions of your hands aren't affected when using it with a camera attached. The Sportsman Mount is the key to properly attaching a GoPro to various shooting and fishing gear. By replacing the backdoor on the Standard Housing with a flush mount attachment point and a special grip, it reduces recoil and other effects of sudden, horizontal motion.

FIREARMS SAFETY GUIDELINES

One of the first things you'll notice when opening the box the Sportsman Mount comes in is a warning regarding proper firearms safety — specifically, to avoid mounting cameras while firearms are loaded. Good advice, as I've heard of a case where individuals were shot while taking selfies with their guns. Also, before heading out into the field with a GoPro on your bow or rifle, do some preliminary research about your local laws. As you'll see on the reverse side of the warning label, some areas don't allow cameras to be mounted to hunting equipment. In those cases, you could attach your camera to a nearby object or even yourself using your favorite GoPro mount.

1. Remove the backdoor from the Standard Housing and replace it with the matching backdoor from the Sportsman Mount kit.

2. Attach the clamp from the Sportsman Mount kit to the backdoor.

3. Secure the grip and optional risers to the bow facing forward, only at points of appropriate width, while avoiding obstructions.

4. Adjust the angle of the mount to follow the path of the arrow.

5. Alternately, mount the grip on other side of the bow, facing away from your target, for close-up views of the archer and arrows.

6. Adjust the angle and height of the mount, making sure to avoid the flight path of the arrow's feathers and other obstructions.

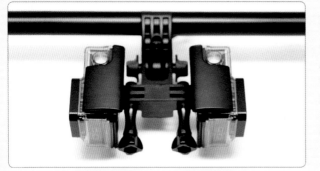

Double Mount

One of the options that ships with the kit is a Double Mount for attaching two cameras simultaneously — for example, with one looking down the side barrel of a gun and the other looking back at the shooter. These perspectives can lend your images a video game–like quality.

Ride a Horse

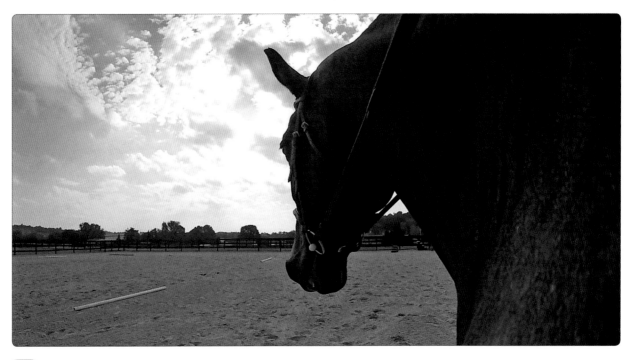

⚡ **MODERATE**

EQUIPMENT

Standard Housing

Head Strap or Chesty

The Strap

Whether for competition or recreation, riding a horse offers a variety of opportunities to capture with a GoPro the actions of these beautiful creatures.

Planning the Shot

While horses can be shaky subjects for a GoPro, they are worth the effort to capture. Wearing a camera on your helmet using the Head Strap offers the widest views. For more intimate perspectives, the Chesty is a good option, as well as any custom mounting positions on your hands, wrists, and boots using The Strap. Mounting decisions with the camera in the Standard Housing are numerous, so experiment within safety guidelines and your horse's comfort level. While maintaining a level horizon can be difficult, the best views are obtained with vertical resolutions, such as 1440p and 2.7K 4:3 (or one of the SuperView modes). High frame rates, such as 48 or 60 fps, slow down the rapid motion of the horse's movement.

1. Use the Head Strap to mount your GoPro on a riding helmet. Alternately, wear your GoPro with the Chesty.

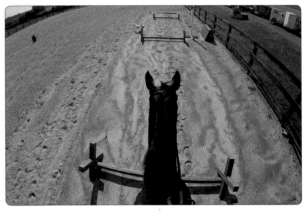

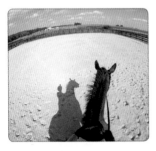

2. Choose one of the vertical resolutions on your camera (such as 1440p, 2.7K 4:3, or SuperView) and adjust the angle to match.

3. Tilt the camera downward enough to capture your horse and any obstacles and jumps in the path ahead.

4. Next, put the camera on your hand or wrist using The Strap. You may need to adjust your usual method of holding the reins.

5. Notice the perspective that's created by moving the camera closer to the horse. (This is similar to using the Chesty.)

6. Finally, place the camera on your boot using one of the longer straps included with The Strap mount.

7. Whenever possible, make turns toward the side with the camera on your boot. This creates a more intimate view of the horse.

Experimenting with Views

Try camera positions that offer dramatic views but are still secure and comfortable for the horse. For example, you could place the camera on your horse's head and get an unusual point of view.

Glide Across the Water in a Kayak

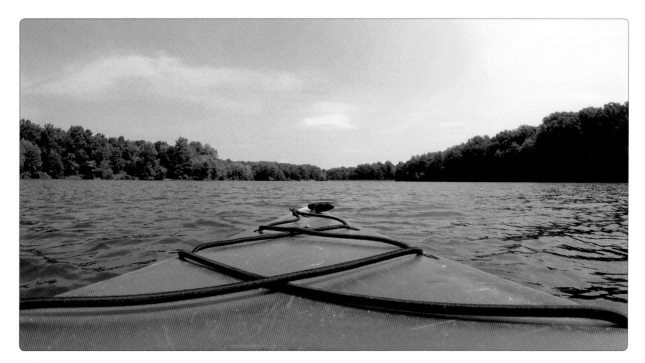

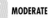 **MODERATE**

EQUIPMENT

Standard Housing

Floaty Backdoor

Adhesive Anchor

Camera Tether

Suction Cup

RAM Mount (Optional)

Whether it's a relaxing day on the water or an expedition down a wild river, you can take the GoPro along for the ride to record your excursion.

Planning the Shot

There are several possible methods to attach a GoPro to a kayak. For the easiest positioning, the Suction Cup is often a good option, depending on the amount of flat surface on your vessel. You can use the standard Suction Cup sold by GoPro or a third-party device, like those sold by Kayalu with RAM mounts attached. Make sure to clean the surface well before attaching the Suction Cup, and avoid any imperfections on the exterior that might compromise the cup's seal. After you've determined your favorite angle, consider installing one of the standard GoPro adhesive mounts (Flat or Curved) for future adventures. However you mount it, always use the Floaty Backdoor and some form of tether when possible, or even gaffer tape if you have it handy, to secure your camera.

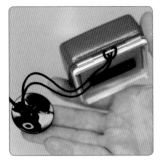

1a. Replace the backdoor from the Standard Housing with the Floaty Backdoor. Attach the Adhesive Anchor to the Floaty Backdoor with a Camera Tether.

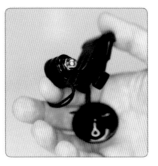

1b. Alternately, after replacing the backdoor, pass the Camera Tether through a hinge or other mounting points on buckles, making certain it's secure.

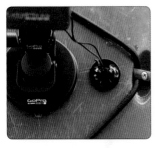

2. Clean the surface of the kayak with water. Attach the Suction Cup mount to its surface, and add the Adhesive Anchor for security.

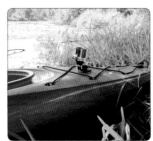

3. Adjust the location and angle of your GoPro for the best view of the kayaker, or turn the camera around and film the water.

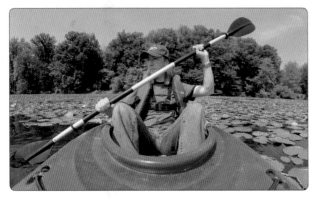

4. You can fill the frame with more of the kayak and water, or angle the camera upward to view more of the sky.

5. For more unique shots, consider repositioning your camera by attaching a RAM mount to the Suction Cup.

6. You can frame a third-person view of kayaker and experiment with interesting perspectives with the RAM mount attachment.

Recreational

In the Driver's Seat with a Dash Cam

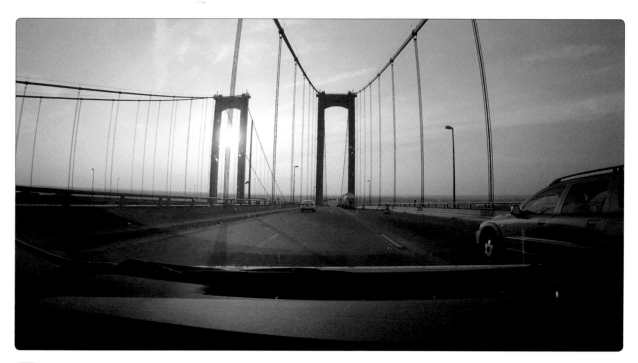

⚡ **EASY**

EQUIPMENT

The Frame
Suction Cup
Flat Adhesive Mount (Optional)
USB Cable
USB Car Charger

Chronicle a road trip, protect your rights during traffic stops, document accidents, or even capture a meteorite streaking across the sky using a GoPro as your dash cam.

Planning the Shot

Proper placement of a dash cam is easy with the Suction Cup mount. Typically, cameras are placed near the rearview mirror to keep the camera mostly out of your field of view, provide natural coverage of your windshield, and minimize unwanted reflections (though a polarizing filter could help with the last). Additionally, consider whether you want the view to be wide, medium, or narrow. In general, the medium view is most natural and provides a good amount of information, although a wide view can be nice for epic vistas. Using the looping video feature takes the guesswork out of recording, and higher frame rates (48 or 60 fps) capture details in motion. For lasting power, simply plug your camera into a USB car charger.

1a. Use the Suction Cup to attach your GoPro (situated in The Frame). Flip the camera's Orientation so the images aren't upside down.

1b. Alternately, attach the Flat Adhesive Mount to the windshield behind the rearview mirror for a more permanent dash cam solution.

2. Plug the camera's USB cable into your USB car charger. Just remember to unplug it when not in use to preserve your car battery.

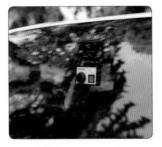

3. Adjust the brackets to get the best view through the windshield without obstructing your visibility.

4. Road test your camera to find view modes and angles that work best for your car and driving conditions. (Medium view is shown here.)

🎥	Video
⏱🎥	Time Lapse Video
🎥📷	Video + Photo
🔁	Looping

5. Activate Looping as your Video mode to continually capture and overwrite your video—manually stopping recording to keep certain clips.

<	**Interval**
Max	✓
5 Minutes	

6. Choose an appropriate Interval length, such as "20 Minutes" or "Max" if you're using the camera on long drives.

7. Take your GoPro with you to document road trips and vacations, in addition to everyday uses.

Explore Trails on a Bike

EASY

EQUIPMENT

Standard Housing

Handlebar/Seatpost/Pole Mount

A favorite pastime and mode of transportation, bikes offer many options for capturing views of riders, their vehicles, and their surroundings.

Planning the Shot

When mounting a GoPro on a bike, the standard location for obtaining the best views of scenery (when facing forward) or the rider (when facing in reverse) is the handlebars. However, the bicycle frame offers many possibilities for attaching cameras via the Handlebar/Seatpost/Pole Mount. With this mount, it's possible to shoot the feet, frame, body, and terrain in different combinations, depending on the frame size of the bike you're using. You can adjust for views of the rider or anything else that interests you in the surrounding environment. The 4:3 aspect ratio of 1440p mode offers the tallest view without distorting like SuperView. And by using higher frame rates (such as 48 or 60 fps), you can capture fast motion better.

1. Using the Handlebar/Seatpost/Pole Mount, attach the GoPro to the handlebars, centering the lens over the pivot point.

2. Angle your camera slightly downward to show the bike's tire, as well as its path (shown here in 1440p).

3. Turn the camera around on the handlebars to face the rider.

4. Adjust the camera's angle to get the best view of the rider, scenery, or sky.

5. Next, attach your camera to the bike's frame between the seat post and pedals for a forward perspective that captures the bike in action.

6. Set the camera to 1440p for a view that includes the bike's handlebars, along with the rider's feet and legs.

7. Experiment with attaching the camera to other bars on the bike, such as this location looking backward.

8. Notice how this view, facing backward, provides a better view of pedaling and the receding scenery.

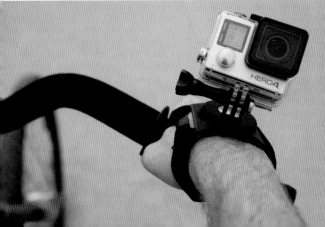

Using The Strap

Beyond the Handlebar/Seatpost/Pole Mount, The Strap can be a quick and flexible way to switch between the rider and a different perspective.

Design a **Kinetic Skateboard Shot**

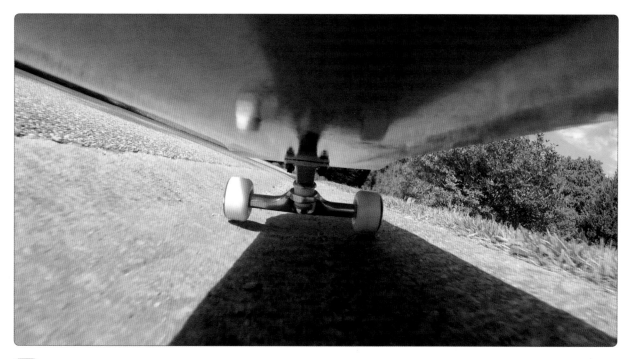

EASY

The fast, frenetic action of skateboard riding requires unusual shots that a GoPro camera is capable of delivering.

Planning the Shot

The best skate videos feature lots of interesting camera work that highlights the mobile athleticism of its subjects. In order to capture skaters and their environment, as well as to heighten the effect of motion, many photographers often use wide-angle lenses. Fortunately, a GoPro's lens is designed for this sort of thing. Half of the fun is inventing new angles or ways to look at the action. Try out mounts that can be worn or held in the hand—anything that can get low to the ground or include a shot of the board is best. And while taping your camera to the bottom of a board requires caution so you don't damage it, this option gives you another way to capture shots at an interesting angle.

1. Attach the Protective Lens to your GoPro. Strap the bare camera to the bottom of your skateboard using gaffer tape, if you dare.

2. Limit your tricks to those that won't cause damage to the camera while it's taped under the skateboard.

3. For shooting images from down low, attach your GoPro (fitted in the Standard Housing) to the 3-Way arm.

4. Despite the small size of the 3-Way, you can get shots that include both the board and its surroundings.

5. Move the 3-Way around to capture different angles whenever possible, taking shots from above while you skate.

Attachment Alternatives

For a good downward view of the skater and the board, you can use the Head Strap and angle the camera down. For a more up-close perspective, clip the Jaws: Flex Clamp onto the ends of your board, facing in or out. The Strap is another versatile option, because it can be mounted on the hand, wrist, legs, or ankles.

Fly a GoPro with Balloons

MODERATE

Helium Balloons

Helium Tank (Optional)

Platform Material

Clear Fishing Line

Tape (Optional)

Fishing Pole, Kite Reel, or Stick

Have helium balloons left over from a party? With some light crafting, you can attach them to a GoPro and float it above your yard or anywhere else you dare.

Planning the Shot

Lifting a GoPro with balloons requires a decent amount of helium, so heft is a major consideration. Twenty or more large balloons isn't unreasonable, with Mylar (polyester film or plastic sheet) being the lightest. Try reducing weight anywhere you can, starting with the GoPro housing—it's best to fly your camera naked. Also, select a platform material that can safely support the camera but is also extremely light, such as Styrofoam (polystyrene foam). Once you've cut out a suitable housing for the camera, strap the camera to the platform, attach the balloons, and balance the craft properly. A small fishing rod or kite reel is ideal for both securing your line and giving you control over ascent and descent.

1. Buy prefilled balloons from a party store or fill balloons using a helium tank. Larger, lighter balloons are best.

2. Cut out a platform for the GoPro, opting for the lightest material possible. Secure the balloons together with their ribbons or clear fishing line.

3. Tie the balloons to the platform with clear fishing line. Balance it with the camera securely attached with tape or line, adding or subtracting weight where necessary.

4. Wrap the fishing line around a small fishing pole, kite reel, or stick so you can tether the craft and reel it in or out.

5. Slowly unspool your line and monitor your camera using the GoPro app.

6. If you're flying it outdoors, use extreme caution. You don't want your camera to fly away or come crashing down.

Sending a GoPro Into "Near Space"

Weather balloons travel to the edge of space on a regular basis (specifically, the troposphere and stratosphere), carrying instruments that collect a variety of information. Some GoPro users have attached their cameras to these high-altitude balloons, capturing stunning views of our planet and a fascinating process of ascent and descent. Surprisingly, these GoPros come back in one piece, surviving shocking temperatures and changing pressure. Because air currents can carry these balloons a good distance, people who have attempted this also attached GPS trackers so they could retrieve the camera footage.

On the Move with Vehicle Exteriors

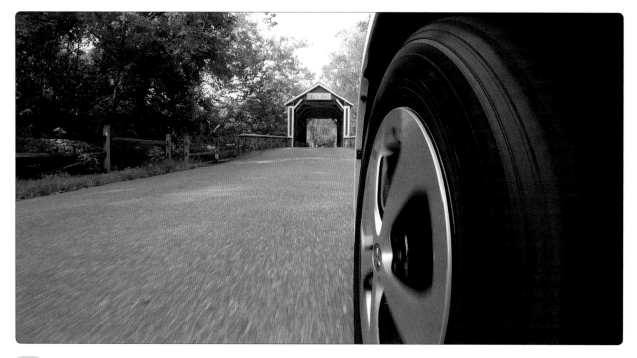

MODERATE

EQUIPMENT

Standard Housing

Suction Cup or Strong Magnetic Mount

Neutral Density (ND) Filter (Optional)

Want to go from leisurely drive to action movie drama? Turn any car into a Mad Max–worthy star by mounting the GoPro on its exterior.

Planning the Shot

Due to their small size and weight, it's possible to mount a GoPro inserted in the Standard Housing almost anywhere. If you have the Suction Cup or a strong magnetic mount, placing the camera on a car is fairly simple. However, you must ensure it doesn't fall off, particularly at high speeds. Although the Suction Cup is surprisingly strong, you can use a tether to tie your camera down if you'd like extra peace of mind. Once you find the right mount for your camera, try out multiple mounting positions, along with different maneuvers to accentuate their effect (having the tires turning into or away from the camera, for example). Just leave the stunts to the experts. Also, for a more natural motion blur while driving, use an optional ND filter to lower the camera's shutter speed.

1. Mount the camera on the driver's-side door near the mirror using the Suction Cup or a strong magnetic mount.

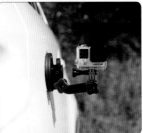

2. Adjust the brackets on the mount to make the camera level, even when mounted on the angled surface.

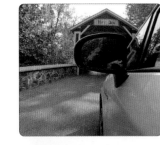

3. Notice how this view shows the car, the opposite lane of the road, and sometimes even the reflection of the driver in the mirror.

4. Next, mount the camera farther back on the driver's side, such as on the passenger door.

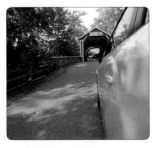

5. Compare this view to the earlier shot near the mirror, and notice how its view is more exaggerated.

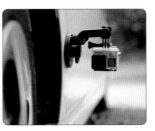

6. Now place your camera on the hood of the car for a view looking backward at the windshield, or even down the hood toward the road.

7. Notice how images of the windshield and hood distort at this distance.

8. Finally, experiment with unique perspectives that only a GoPro can easily achieve, such as near the tires.

9. For instance, create extreme motion by placing your camera close to the ground, angling it toward the car or angling the tires toward it on turns.

Create a **Cable Cam Shot**

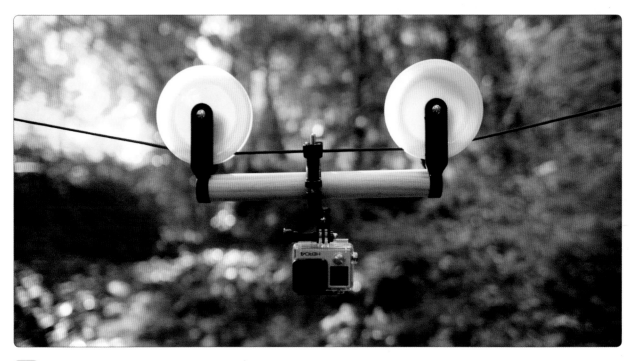

ADVANCED

With a few inexpensive items and tools, you can send your camera flying through the trees or accurately track a subject over long distances.

EQUIPMENT

Saw

Electric Drill

Philips-Head Screwdriver

Two Pulleys

Dowel Rod

Two #14 × 1¾-Inch (4.5cm) Screws

Handlebar/Seatpost/Pole Mount or Roll Bar Mount

Nylon Clothesline or Paracord

Planning the Shot

Due to their size and weight, GoPro cameras are ideal for use in homemade devices such as a cable cam, which is basically a zip line for cameras that allows you to capture smooth, high-angle tracking shots. Although gravity—or a string tied to the mount—will do the work of moving the device, make sure to slow it down or stop it before it hits a tree or other anchor point. You can do this by testing and adjusting the angle of your line before use, leaving some slack in the line, or using extra strings tied to the camera rig to grab it before it reaches the end. Sway of the device may be reduced by adjusting its center of gravity (moving the camera closer to the line, for instance) or adding weights (such as a water bottle hanging off the center).

1. Acquire an electric drill, saw, and Philips-head screwdriver.

2. Decide the size of the pulleys you want to use. In this example, 4-inch (10cm) pulleys are used.

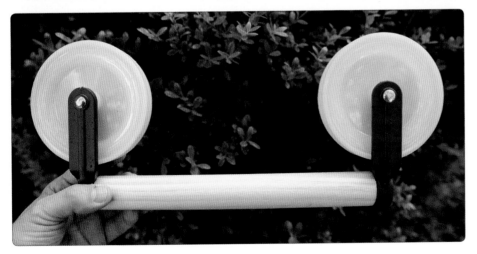

3. Cut a thick dowel rod to approximately 10 inches (25cm) in length and predrill holes for the screws in each end. Attach the pulleys with two #14 × 1¾-inch (4.5cm) screws on each end.

4. Attach the Handlebar/Seatpost/ Pole Mount or Roll Bar Mount to the center point. Other mounts, such as adhesives or permanent solutions, may be used as well.

5. Obtain some nylon clothesline or paracord to match the size of your pulleys.

6. Securely tie one end of the cable to an anchor point.

7. Slip the cable cam onto the cord and test the motion by raising and lowering the height of your cable. When ready, anchor the other end of your cam system.

8. Line up the cable cam on the high end of the cord and release, making sure to slow down your GoPro on its descent.

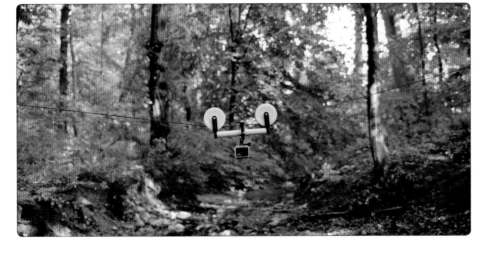

9. Review your footage and adjust the balance of the camera, adding weight if necessary.

Creative

Shoot a Music Video with a Guitar

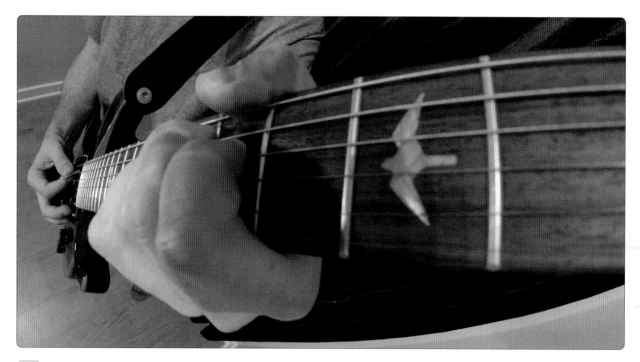

EASY

Whether it's guitars, drums, keyboards, or turntables, music videos frequently include a "live" performance with an instrument. GoPro cameras can add excitement and energy to footage shot onstage or in the studio.

Planning the Shot

While you can apply these techniques to a wide variety of instruments, in this project, you learn how to attach your GoPro to a guitar. Frequently, the two most useful positions for filming a guitar are from the headstock—looking down the neck—or from the body of the guitar. Use these positions as starting points for experimentation. If you're recording instructional videos, these camera angles may also provide viewers with a better view of your hand and finger positions. Close-up views of the performer can be achieved with some careful positioning of The Jam. If you want your video to remain in sync with an audio track, make sure to choose matching frame rates, such as 24 or 30 fps, for your entire shoot. Slow-motion frame rates, such as 120 fps, can be used for a dreamlike effect in a music video.

1. Insert the GoPro into The Frame for the lightest, lowest-profile mounting option.

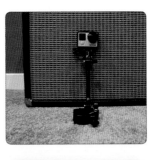

2. Attach the GoPro to The Jam or the Jaws: Flex Clamp.

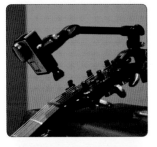

3. Attach the clamp to the guitar.

4. Adjust the clamp to your desired angle, with a clear view of the instrument fretboard, the performer, or both.

5. To switch positions and attach the camera to the guitar body, first clean the guitar surface with a microfiber cloth.

6. Peel off the backing from the adhesive of the Removable Instrument Mount. Press and hold onto the body of the guitar.

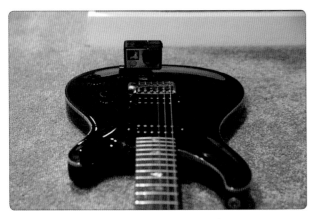

7. Attach the GoPro to the Removable Instrument Mount on the guitar.

8. Get up-close-and-personal shots of playing with the mount on the guitar body.

Set Up to Record a Concert or Event

EASY

EQUIPMENT

The Frame or Skeleton Housing

3-Way

Mic Stand Mount (Optional)

3.5mm Mic Adapter

Capture video and audio of a live event at a large stadium or an intimate club and share it with your family, friends, or other followers online.

Planning the Shot

Unless you're lucky enough to be outside on a sunny day, you should adjust your settings for low-light and mixed-light situations, which are typical for concerts. Use slower shutter speeds (such as 30p), as well as Protune settings with the lowest ISO, to reduce noise. Also, depending on the lighting environment, you may need to use the Spot Meter (which bases the exposure on the center of your frame) or EV Compensation (which adjusts the overall exposure up or down). Because sound is important for most events, use The Frame or the Skeleton Housing for clearer audio capture, to access ports for external mics, and for additional power. Have a tripod or mic stand within reach to hold the camera steady, as well as a wide selection of mounts and adapters for attaching your GoPro to stages, pipes, and other impromptu mounting locations.

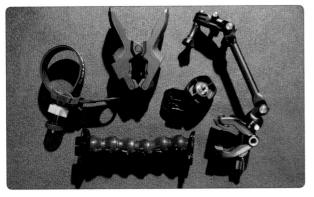

Color	GoPro Color >
ISO Limit	400 >
Sharpness	Medium >
EV Comp	————●———— -0.5
Reset Protune	

1. Bring along a bunch of mounts so you have the option of attaching your camera to diverse spots at a venue.

2. In the camera's Settings menu, turn on Protune. Adjust the Protune settings, such as EV Compensation, to account for spotlights and other difficult lighting.

3a. Attach your camera to the 3-Way mount for extra reach at a concert or other events.

3b. Alternately, for more versatile positioning, use the Mic Stand Mount to attach your camera to a mic stand.

4. Using the 3.5mm Mic Adapter, you can also connect your GoPro to the audio mixer at a venue for a direct feed of sound from instruments, singers, or speakers.

Live Stream an Event

It's possible to stream live video from your GoPro, sharing experiences and events in real time. In order to do this, you'll need an iOS or Android app (such as Livestream) and a 4G connection. Advanced video producers can use GoPro's professional HEROCast option.

Construct a **Forced-Perspective Shot**

EASY

EQUIPMENT

Tripod Mount Adapter

Tripod

Creating the illusion that objects are closer or farther away from the camera makes for some fun tricks with perspective that can delight viewers of your images.

Planning the Shot

Tricking the eye into thinking objects or people are a different size than they are in reality isn't difficult to do. This technique has been used in movies for a century, creating dinosaurs that loom over figures in B-movies or making hobbits out of ordinary actors. You've probably produced this effect in its simplest form already, such as "holding" the Eiffel Tower between your fingertips from a distance. With a little extra effort, you can create even more interesting scenarios. Toys are a great place to start. Making a small toy appear to be the same size as a person, for example, requires some basic measurement of scale and distance.

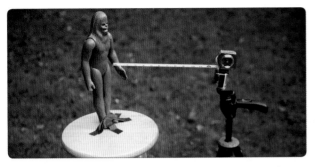

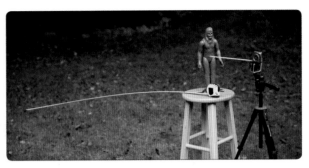

1. Using the Tripod Mount Adapter and a tripod, set up a shot with the toy in the foreground, approximately 12 inches (30.5cm) or more away from the camera.

2. Calculate the toy's approximate scale (such as 1:6 scale), multiply the second number by its distance from the camera (in this case, 1 foot [30.5cm]), and move that distance away from the toy (6 feet [1.75m]).

3. Use the GoPro app to line yourself up with the foreground, and then take the shot.

4. Notice the actual scale of the toy in relation to the person from the previous shot.

SIMPLE FORCED-PERSPECTIVE SHOTS

You can use forced perspective in its simplest form by aligning your hand with a distant object and "holding" it between your fingers. You can match photographs with a background using the same technique.

Forced-Perspective Shots in Movies

The use of forced perspective is as old as Hollywood itself. Sets were (and still are) often created with elements that recede in size, emphasizing the foreground elements. And as mentioned, actors are sometimes incorporated into backgrounds or with people of varying sizes at different distances. While set design lighting and camera angles must be flawless, the effect saves on additional CGI.

Spin a GoPro to Create Abstract Visuals

EASY

EQUIPMENT

Suction Cup

Neutral Density (ND) Filter

Rubber Bands

The creation of abstract visuals is a fun and oddly satisfying pursuit because it's very easy to do. Spinning your GoPro can yield beautiful, one-of-a-kind graphics.

Planning the Shot

Spinning a GoPro can be achieved in numerous ways. A risky but natural option is to put your camera on a car wheel and use the vehicle's natural locomotion to rapidly turn it around. If you attempt this shot, make absolutely certain the Suction Cup is secure and limit the speed you drive, starting very slowly at first. Also, use an ND filter to lower the camera's shutter speed; this results in more motion blur and better circular patterns. Another option is to attach your GoPro to rubber bands, a string, or anything else you can think of; turn the camera to twist the attachment; and then release to create an interesting whirling pattern for your image.

1. Attach your camera to a rear wheel (in case it falls off) using the Suction Cup mount, ideally tethered for added security.

2. Add an ND filter to the camera. Drive slowly, gradually picking up some speed as you go.

3. Review the camera's footage and choose individual frames you find interesting, unique, or just plain mesmerizing.

4. To create other abstract visuals on the fly, attach a rubber band to each hole in the bottom of your GoPro's case.

5. Twist your camera while holding the rubber bands, and then release to start it spinning.

6. Find a location to spin your camera with interesting colors and bright lights for maximum effect.

Beyond Spinning

You can create abstracts even without spinning the camera. Simply expose your camera to a wide variety of colorful objects, surroundings, and screens. For instance, you can place a prism or other optical device over (or in front of) the camera's lens. You can even cover the lens with colored glass and other distorted optics you find around the house.

Make a **Creative Short Film**

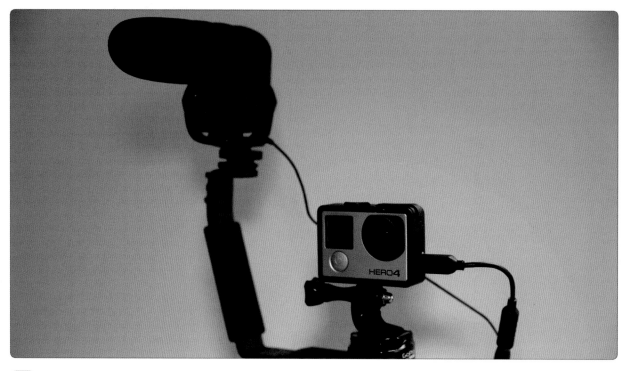

MODERATE

EQUIPMENT

The Frame or Skeleton Housing

LED Lights (Optional)

Directional or Lavalier Microphones (Optional)

3.5mm Mic Adapter (Optional)

Tripod Mount Adapter

Tripod

Suction Cup

With a GoPro, shooting a movie doesn't require a large crew and a lot of equipment. If you have an idea for a short film, now's the time to make it.

Planning the Shot

Using a GoPro to shoot your short film allows you to put the camera places a larger rig wouldn't fit. A tripod is standard practice, though you might opt for a stabilized gimbal or body-mounted camera. Design your shots before shooting to make sure you have the best mounting solution. Also, if your film has dialogue or sound effects, a 3.5mm Mic Adapter can attach better microphones to your setup. While the internal mic will work in a pinch, make sure to use The Frame or the Skeleton Housing for the clearest sound. Experienced users should make adjustments for the highest-quality image capture using the best Protune settings. Recommended settings include a lower ISO Limit of 400 for less grain, low sharpness for smooth footage, a fixed White Balance setting (such as Native), and a Color profile of Flat if you're color-correcting and adjusting footage later on.

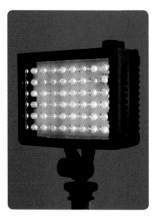

1. Properly light your subjects using existing sources, or purchase inexpensive LED lights, making sure to set the White Balance in the Protune settings.

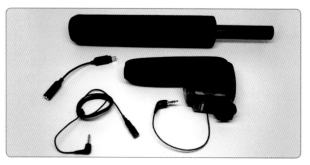

2. If you'd like to improve the sound recording, attach directional or lavalier microphones to your GoPro using the 3.5mm Mic Adapter.

3. Create shots that are impossible with larger cameras, such as a character getting letters out of a mailbox as seen from within.

4. Place the camera low to the ground (or high up) using a tripod and Tripod Mount Adapter to accentuate wide angles and motion.

5. Attach the camera inside cars for driving and dialogue scenes, using mounts such as the Suction Cup to obtain multiple angles.

Third-Person Camera Mounts

Backpack and belt-mounted products exist to help you achieve a unique, third-person camera view with your GoPro. Typically, this is an over-the-shoulder perspective, similar to what you've seen in video games with the camera closely following a character. Sail Video System's 3rd Person View camera mount is a popular option to achieve these shots. The effect is hands free and perfectly locked to a subject's movement. It's one of those shots that makes people ask, "How'd they do that?"

Green Screen

For visual effects mavens, use a green screen to transpose shots of actors into new backgrounds captured with a GoPro, matching lens distortion.

Levitate with Your GoPro

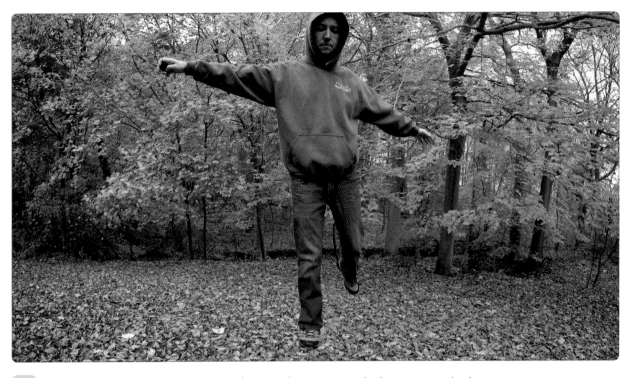

MODERATE

EQUIPMENT

Tripod

Tripod Mount Adapter

Smart Remote

Floating above the ground doesn't only happen in your dreams. This levitation effect is also possible using a GoPro and a few simple techniques.

Planning the Shot

Creating the illusion of levitation differs somewhat depending on your choice of motion video or still photography. If you're shooting still photos, this means you simply jump and shoot, capturing the moment when you've reached the apex of your jump. This can be tricky—especially if you want to look natural doing it. However, even though it requires some trial and error, you can use Burst mode in combination with the Smart Remote to achieve this. Just make sure there's enough light to avoid motion blur. The jump-and-shoot method works better for video, because you can jump, move, and jump some more to create a time-lapse effect. You can then select only the best still images in post, effectively removing the frames in between your ascents and descents. While the process can be a bit tiring, it's worth the effort.

1. For still photos, attach your GoPro to a tripod using the Tripod Mount Adapter. Set up the shot and enable Burst mode using the Smart Remote.

2. Jump up and, with the Smart Remote, trigger the shutter as you start to leave the ground. Later on, choose the best peak shot.

3. For video, set up a wide shot and enable the Video mode on your GoPro using the Smart Remote.

4. While recording, jump straight up in the air (keeping a uniform posture), move one small step, and repeat until you've created a series of jumps along a path.

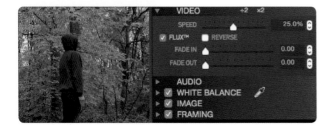

5. Import the video into GoPro Studio and click Add Clip to Conversion List and then Convert. Add the converted clip to the Storyboard in a Blank Template.

6. Locate the exact frame where your jump reaches the apex and choose Share > Export Still, saving it to a new folder. Repeat for each apex shot.

7. Import the video into GoPro Studio and click Add Clip to Conversion List and then Convert. Add the converted clip to the Storyboard in a Blank Template.

"Levitating" Using Photoshop

Set up a stool and in Photo mode shoot yourself lying or standing on it. Next, take a shot of the exact position without the stool or you in it. In Adobe Photoshop, you can remove the stool by placing the "clean" background on the bottom layer (under the layer containing the shot of you and the stool) and then use the eraser tool on the stool to reveal what's underneath.

Create a **Panorama**

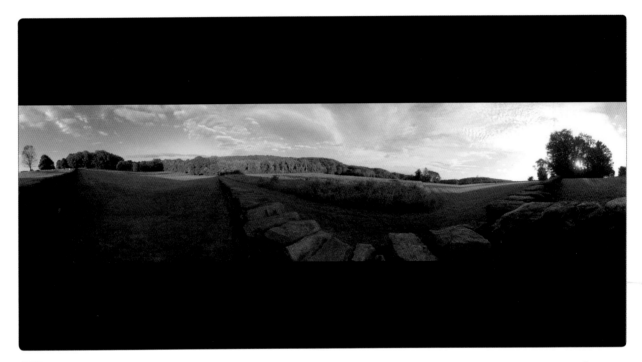

ADVANCED

EQUIPMENT
Tripod Mount Adapter
Tripod

If the standard views from a GoPro aren't wide enough, create a panorama to capture your favorite vista in all its glory.

Planning the Shot

Panoramas are great for creating immersive photos of epic landscapes. While GoPro cameras are already quite wide, you can get even wider and include your entire surroundings by combining multiple photos taken from a single location. Views that are far away won't render as much detail, and subjects that are too close may distort, making stitching difficult. However, for ordinary horizontal panoramas of a landscape, it's good to have some features that are a bit closer to the camera. The most difficult part of a panorama is making sure you've captured the images correctly. Keep the camera level throughout your pans, and overlap each shot by 30 to 50 percent, so stitching software can align them. A tripod is ideal for stable pans, as long as it remains level. You can pan with your hands as well by rotating carefully as you shoot.

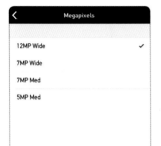

1. Set your GoPro to Photo mode and select the highest quality possible for your camera, such as 12MP Wide.

2. Attach your GoPro to a tripod via the Tripod Mount Adapter. Rotate the camera in fixed increments, like the hands of a clock, pressing the shutter each time.

3. Copy the images to a new folder on your computer and preview your shots, deleting any extra photos.

4. Import the photos into Adobe Photoshop and use its Photomerge function, or use a free utility like the trial version of PTGui.

5. Remove lens distortion by checking that option (Geometric Distortion Correction here) before attempting to stitch images together, which is an option in most photo-editing software.

6. Use automatic stitching to seamlessly align and blend your images together. Crop the panorama.

360° Panoramas for Virtual Reality

In recent years, virtual reality (VR) applications for still and video panoramas have increased exponentially. In particular, the use of spherical (360×180°) video has become popular, with several companies (GoPro included) staking their claim to content creation tools. One such company, called 360Heros, makes rigs that hold from 6 to 14 GoPro cameras in a ball-like configuration. Once shot and stitched together into a single stream, you can view the video from any angle you wish at any point in its playback. From concert and event production to narrative projects, the possibilities for using VR via panoramas are very enticing.

Time

Pop a Water Balloon in Slow Motion

 EASY

EQUIPMENT

Standard Housing

Water Balloon

String

Tripod Mount Adapter

Tripod

Jaws: Flex Clamp (Optional)

Sharp Object (Such As a Knife)

Let's not forget about the simple pleasures in life. Popping water balloons is not only a good stress reliever, but also an opportunity to capture an amazing slow-motion video.

Planning the Shot

With the Hero4 Black camera, you can record up to 240 fps at a video resolution of 720p. This extremely slow motion enables you to smoothly capture fast actions, such as athletes jumping or water balloons popping. If you're using the Hero4 Silver, you can shoot up to 120 fps at 720p; this is still good, but not always ideal. When your footage isn't slow enough, use the Flux feature in the GoPro Studio software to slow it down even further. One caveat to shooting at these frame rates is it limits the Field of View to "Narrow," so give yourself a little more distance from your subject than ordinary. With this project, it's probably not a bad idea anyway—unless it's a hot day and you don't mind getting wet.

1. Set your GoPro to Video mode, 720p, 240 fps.

2. Fill the water balloon, tie a string around the end, and find a good spot to hang it.

3a. Position the GoPro on the Tripod Mount Adapter attached to a tripod facing the action.

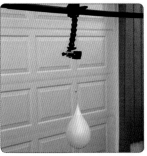

3b. Alternately, attach the camera to the Jaws: Flex Clamp and place it above the balloon.

4. Use the GoPro app to frame the action.

5. Pop the balloon with a sharp object (such as a knife). Enlist the help of an assistant, if necessary.

6. Enjoy the random water patterns that result from the popped balloon by stepping through the video playback frame by frame.

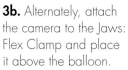

Precautions for Shooting Slow-Motion Video

Shooting slow-motion video requires a lot of light, because the camera's shutter speed is partially determined by the frame rate. At 240 fps, for example, a minimum shutter speed of 1/240 is required. Therefore, you want to have as much light as possible to have the high shutter speeds necessary for slow-motion imagery. Also, at these speeds, some lights may appear to flicker, particularly florescent fixtures. While it's difficult to predict when this will occur, you can avoid this by using professional fixtures or shooting in sunlight.

Control the Clock with a Time Lapse

 MODERATE

EQUIPMENT

Tripod

Tripod Mount Adapter

Battery BacPac or USB Power Source (Optional)

Smart Remote (Optional)

Using a time lapse to speed up motion, such as clouds traversing the sky, just got easier with the Time Lapse Video mode on GoPro cameras.

Planning the Shot

Achieving good time-lapse results depends on the subject you've selected, a rock-solid tripod, and a lot of luck. A tripod is necessary for stabile images that don't shake or jitter, particularly when subjected to wind or surface vibrations. Make sure to choose something that has plenty of interesting motion. Nature subjects, such as a blooming or withering flower or clouds moving against a landscape, are good choices. With a GoPro Hero4 camera, you can create the time lapse without manually assembling a series of still images (the traditional method). Instead, you use the Time Lapse Video feature to automatically compile a sequence of images into a video file, ready for playback as an MP4 file.

1. Set up a sturdy tripod you're certain will remain stable over a long period of time with the Tripod Mount Adapter. Attach the camera.

2. If you'd like to do extended shooting, attach the Battery BacPac or a USB power source to your camera.

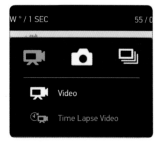

3. On your camera, choose Video mode and select Time Lapse Video. This records frames into complete video files instead of stills.

4. Select a subject with interesting foreground and background elements. This can include landmarks, which offer instant recognition.

5. Trigger your camera to shoot using the GoPro app on your phone, or use the Smart Remote to avoid shaking your camera.

6. For a new time lapse, with your camera attached to the tripod via the Tripod Mount Adapter, aim at the sky.

7. Record the transit of the clouds and sun. You can use foreground trees for their fluttering motion, which adds interest to the time lapse.

Indoor Time-Lapse Video Ideas

You don't need to focus on outdoor subjects only in time-lapse videos. You can select everyday topics to explore in your home, such as melting ice cubes or lights and shadows moving across the floor.

Create a **Stop-Motion Animation**

MODERATE

EQUIPMENT

Tripod

Tripod Mount Adapter

LCD BacPac (Optional)

USB Power Supply

Smart Remote

Despite the focus on computer-generated animation, stop-motion animation remains popular, in part, for its handmade feel. Now's your chance to give it a try.

Planning the Shot

While GoPro cameras generally lack support from professional stop-motion software, that doesn't mean you can't get interesting results. You can animate almost anything, from common objects around the house to clay characters. When it comes to setup, figure out the lighting and backdrop you'd like to use, and, if you're working with characters, make sure to have a steady surface with good attachment points for movement. Once that's all settled, mount your camera on a rock-solid tripod and use the Smart Remote to trigger your shots. Calculate the duration of a shot by dividing the number of frames you shoot by the frame rate. For example, 48 frames of an animation create 2 seconds of video at 24 fps. While obtaining interesting or natural-looking motion is maddeningly difficult to get right, you can achieve simple movements, such as an object or character moving across a surface.

1. Choose Photo mode and set the camera to Single shot. Place the camera on a tripod via the Tripod Mount Adapter.

2. Turn on Protune and manually set the White Balance based on your lighting setup.

3. Attach the LCD BacPac to preview shots, or monitor your setup with the GoPro app.

4. Set your starting position for the first shot. With a USB power supply attached, you should have enough power to avoid touching or accidentally moving the camera while shooting.

5. Step aside and use the Smart Remote to trigger your first shot. Make certain not to cast any shadows as you stand by.

6. Gently move the object a little bit, being extremely careful not to bump into any other element in your scene.

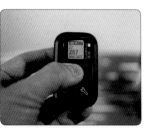

7. Take another shot with the Smart Remote.

8. Once you've accumulated frames for a shot on your video card, open GoPro Studio on your computer, choose Import New File, and select the shot folder.

9. Select Advanced Settings. In the window that appears, set your frame rate to 23.98 (if desired) and click OK to proceed.

Capture Perfect Action with
Burst Mode

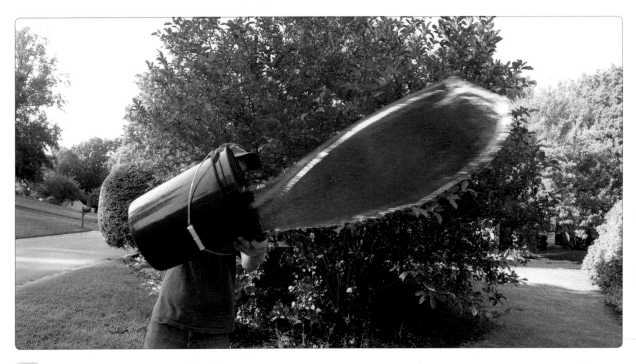

⚡ **MODERATE**

EQUIPMENT

Tripod

Tripod Mount Adapter

Smart Remote

When you want to stop time and maintain image quality, try utilizing Burst mode, which freezes actions using high-resolution photos.

Planning the Shot

The ability to capture a wide variety of action at different speeds is clearly one of GoPro's strengths. With Burst mode, you can take a slice of time as high-resolution photos rather than video. Once you've captured the action, you can extract the still images that best encapsulate the action or show some unique attribute of the subject. This is great for instructive purposes (for example, taking photos practicing your swing in a batting cage) and for simply grabbing the perfect shot of an entertaining action (for instance, when a bucket of water splashes onto someone or a tower of cards collapses). The rate of capture for Burst mode varies from 3 photos a second, to 30 photos a second, to 30 photos in 6 seconds, with several other options in between.

1. Choose Multi-Shot mode. Select Burst.

10 Photos / 2 Seconds
10 Photos / 3 Seconds
30 Photos / 1 Second
30 Photos / 2 Seconds
30 Photos / 3 Seconds

2. Set Rate to the appropriate setting—in this case, a fast "30 Photos/1 Second" for knocking over blocks with a ball.

3. For low-velocity indoor shots, place the camera on a Tripod Mount Adapter attached to a tripod to keep the action perfectly centered and to minimize blur.

4. Preview your shot. When you're ready to perform the action, quickly trigger the camera's shutter using the GoPro app.

5. Review your shots, check the action, and select individual photos using the GoPro app.

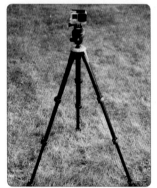

6. For actions that require space, water, or high velocity (such as batting and acrobatics), set up the tripod with the Tripod Mount Adapter outdoors.

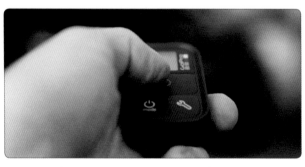

7. Use the Smart Remote to trigger the camera's shutter when the action begins.

8. Review your shots using the GoPro app, scanning the thumbnails to check your results.

Paint Your Name with Light

⚡ **MODERATE**

EQUIPMENT

Flashlight or Laser Pointer

Tripod Mount Adapter

Tripod

Smart Remote (Optional)

LCD BacPac (Optional)

Equipped with a handheld light source and your trusty camera, nighttime is a canvas for you and GoPro's Night Photo mode.

Planning the Shot

A small light and a dark space, inside or out, are all it takes to write your name in lights. Anything that produces light, in any color, is a potential writing implement—even laser pointers. Different light sizes, powers, and colors can yield different results. The real difficulty when trying to execute the shot is mastering movements for the invisible script. Because you're facing the camera, it's necessary to mirror your writing (backward and in reverse order), giving yourself enough space so you don't overlap your letters. While successful light painting involves a lot of trial and error, you'll see interesting results on your first attempt. You aren't limited to writing names or text, so be creative. Experiment and have fun!

1. Select Photo mode, and then Night. Set Shutter to 30 seconds, or the longest time necessary to do your "painting."

2. Turn Protune on, set White Balance to 3000K, and choose GoPro Color for Color.

3. Set ISO Limit to 100 for the most noise-free images. Set Sharpness to High.

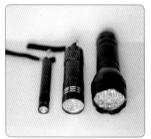

4. Select a light source, such as an LED flashlight or a laser pointer.

5. Use the Tripod Mount Adapter to place your camera on a tripod outdoors in total darkness or in a completely dark room.

6. Use the GoPro app or Smart Remote to trigger the shutter, and then start writing backward and in reverse.

7. Try spinning and twirling the lights to create interesting patterns or to draw shapes or figures in the air.

8. Write special dates, compose love letters, or ring in the New Year with a light painting.

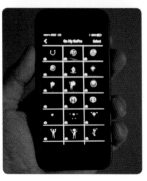

9. Use the GoPro app or LCD BacPac to review your shots.

Create a Night Lapse of a Starry Sky

⚡ **ADVANCED**

Go beyond the limits of your eyes and reveal the mysteries of a starry sky with the Night Lapse feature on your GoPro camera.

EQUIPMENT

The Frame or Skeleton Housing

Tripod

Tripod Mount Adapter

USB Power Source

USB Cable

Battery BacPac (Optional)

Smart Remote (Optional)

Planning the Shot

It's necessary to have at least some light for night lapse to work, meaning a degree of sky glow, bright stars, distant street lamps, or a moonlit night. Partial placement under a tree or other "live" shaking and swaying subject is ideal to give the shot extra energy. However, use caution with stray light sources (such as street lamps); they can cause streaking on the lens and might overexpose your shot. Adjust your exposure to compensate for lighting by taking test shots and trying out multiple positions. Because your Live Preview is completely dark at night, it can be difficult to compose shots. Take several shots, adjust, and settle in for a long night of shooting, or simply leave the camera until morning. If you decide to leave the camera unattended, watch out for dew accumulation or use the Skeleton Housing instead of The Frame.

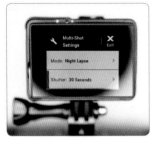

1. Choose Multi-Shot, and then Night Lapse. Set Shutter to 30 Seconds for the maximum amount of light.

2. Set Interval to Continuous.

3. Turn Protune on, and set White Balance to 3000K.

4. Set ISO Limit to 800 for a dark sky or 400 for a bright, moonlit night.

5. Put your camera in The Frame or the Skeleton Housing. Place the GoPro on a tripod using the Tripod Mount Adapter.

6. Connect your GoPro to a USB power source or Battery BacPac for all-night power.

7. Place your camera in an area with an optimal view of the sky and some foreground object, such as a tall tree.

8. Use the GoPro app to review your test shots and trigger recording, or use the Smart Remote to avoid shaking your tripod.

9. In GoPro Studio, choose Import New File. Select the images folder to make a clip from your night-lapse images.

Fast-Forward with a Moving Time Lapse or Hyperlapse

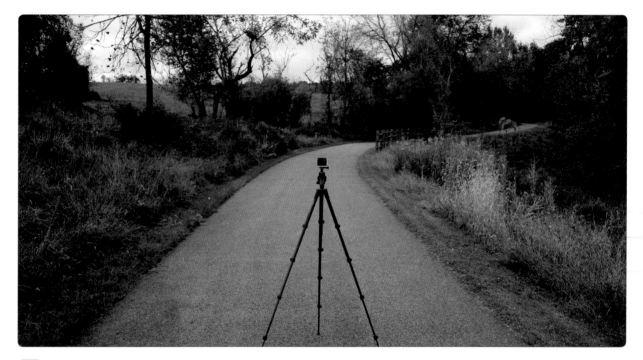

ADVANCED

Tripod Mount Adapter

Tripod

Camera motion adds another layer of energy to your time-lapse projects. Moving the camera, as the world moves around it, can help achieve this.

Planning the Shot

Over shorter distances, a camera slider or short dolly track is ideal for capturing a time lapse. However, moving across a large outdoor plaza, building, or landscape requires more mobility. Placing your camera on a tripod and carefully moving it a fixed distance over a period of time (while snapping photographs at each position) creates a quick, animated time lapse—or hyperlapse—of your route. Users of Instagram's (or Microsoft's) Hyperlapse app already know how much fun it can be to do this while walking in a city, with plenty of fountains, statues, and monuments to be used for hyperlapses that rotate around. The key is keeping the camera level and moving it at fixed intervals, as well as stabilizing your footage later, if necessary.

1. Choose a level surface, such as a sidewalk or plaza. Place your camera on a tripod using the Tripod Mount Adapter.

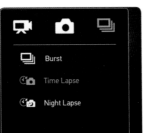

2. Set your GoPro to Photo mode for manual shooting, or Multi-Shot and Time Lapse with an interval of 10 seconds for automatic shooting.

3. Measure out distances with your feet, counting off steps as you go, or utilize bricks and tiles to measure more accurately.

4. Take shots while moving forward, going to the side, or rotating around a fixed point (such as a fountain or statue).

5. Copy your images to a folder on your computer. Preview the motion by stepping through each shot in a file browser.

6. Import your folder containing your time-lapse images into GoPro Studio, which treats them as a single clip, or into Adobe After Effects for stabilization.

Using Egg Timers for a Motion Time Lapse

For a time lapse that pans from a fixed position, many shooters mount their camera on a modified egg timer. You can easily make one of these yourself or buy one from several companies that sell them already adapted for this purpose. Place your GoPro on top, rotate the timer to your starting position, and let it go. An hour or two later, come back to retrieve your camera and review a time-lapse sequence that magically pans across the scene.

Index

N

O–P